THE *Art* OF POSING

*TECHNIQUES FOR DIGITAL
PORTRAIT PHOTOGRAPHERS*

LOU JACOBS JR.

AMHERST MEDIA, INC. ■ BUFFALO, NY

Check out Amherst Media's blogs at: http://portrait-photographer.blogspot.com/
http://weddingphotographer-amherstmedia.blogspot.com/

DEDICATION

To my wife, Kathy, who has posed for a large number of pictures as I tested lenses, placed her in dozens of travel shots, or used her as a model because I think she is beautiful.

ACKNOWLEDGMENTS

Ten talented and experienced photographers contributed chapters for this book, and I am grateful for their help and encouragement. They also illustrated their own chapters, and their photographs will inspire readers as they did me.

Published by:
Amherst Media, Inc.
P.O. Box 586
Buffalo, N.Y. 14226
Fax: 716-874-4508
www.AmherstMedia.com

Publisher: Craig Alesse
Senior Editor/Production Manager: Michelle Perkins
Assistant Editor: Barbara A. Lynch-Johnt
Editorial assistance provided by John S. Loder and Sally Jarzab.

ISBN-13: 978-1-58428-991-3
Library of Congress Control Number: 2009939768

Printed in Korea.
10 9 8 7 6 5 4 3 2 1

CONTENTS

INTRODUCTION . 7
Posing Is An Art . 7
Smiles . 7
Becoming Wiser 9
Predictions . 9
Lighting . 9
Contributors . 9
Influences . 9
Portrait Pointers 10
Exercises . 10
Going Forward 10

JULIA GREER 12
About Your Background 13
Describe Your Studio 14
Your Specialties 14
Getting Acquainted with Clients 15
First Portrait Poses 15
Encouraging Improvisation 18
Inspiring Good Poses 18
The Importance of Lighting 18
Using Props . 21
Discussing What You Are Doing 21
Facial Flaws and Excess Weight 22
Teen Poses . 22
Posing Young Children 22
Posing Groups 22
Clothing for Portraits 22
Digital Alterations 22
Body Language 23
Cameras, Lenses, Flash, and Backgrounds 23

MARISSA BOUCHÉR 24
About Your Background 25
About Your Studio 26
Your Specialties 26
Getting Acquainted with Clients 26

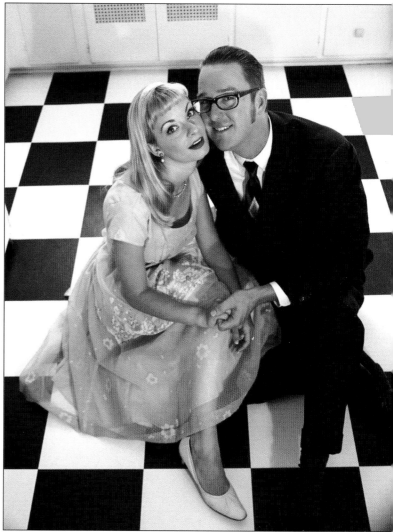

Photo by Elizabeth Etienne.

Preparing Poses 28
First Portrait Poses 28
Traditional Poses 31
Flattering Poses 31
Using Props . 32
Discussing What You Are Doing 32
Posing Groups 35
Preparations and Pricing 35
The Importance of Lighting 35

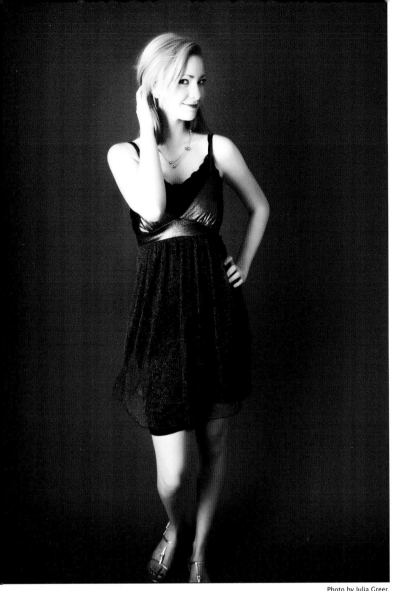

Photo by Julia Greer.

Backgrounds . 35
Cameras, Lenses, and Flash 35

CAROLYN WRIGHT 36
Describe Your Studio 37
Your Specialty . 38
Getting Acquainted with Clients 38
Preparing Poses . 38
First Portrait Poses 41
Improvisation . 41
Inspiring Good Expressions 42
The Importance of Lighting 42
Using Props . 43
Discussing What You Are Doing 43
Facial Flaws and Excess Weight 44
Teen Poses . 44

Posing Young Children 44
Posing Groups . 44
Clothing for Portraits 45
Digital Alterations 45
Body Language . 45
Cameras, Lenses, and Flash 45

ELIZABETH ETIENNE 46
About Your Background 47
Describe Your Studio 48
Getting Acquainted with Clients 48
Preparing Poses for a Shoot 50
Beginning Portrait Poses 51
The Importance of Lighting 52
Using Props . 54
Discussing What You Are Doing 54
Facial Flaws and Excess Weight 54
Posing Older People 55
Posing Young Children 55
Posing Groups . 55
Clothing for Photos 55
Digital Manipulations 55
Body Language . 57
Cameras, Lenses, and Flash 57

MELANIE LITCHFIELD AND
SARA BRENNEN-HARRELL 58
Responsibilities . 59
Your Studio . 60
Your Specialties 60
Getting Acquainted with Clients 61
Portrait Posing . 61
Capturing Moods 62
Family Portraits 62
Variety is Key . 64
First Portrait Poses 64
Encouraging Improvisation 64
Inspiring Good Expressions 65
Importance of Lighting 66
Flaws and Excess Weight 68
Using Props . 68
Showing Pictures While Shooting 68
Digital Alterations 68

Posing Older Folks . 68

Postproduction . 69

Cameras and Lenses 69

RON JACOBSON . 70

More Background . 71

Describe Your Studio 71

Dividing the Work . 73

Your Specialties . 73

Getting Acquainted with Clients 73

First Portrait Poses . 75

Encouraging Improvisation 75

Inspiring Good Expressions 76

The Importance of Lighting 76

Using Props . 77

Discussing What You Are Doing 77

Facial Flaws and Excess Weight 77

Teen Poses . 77

Posing Young Children 78

Posing Groups . 78

Clothing for Portraits 79

Digital Alterations . 79

Body Language . 79

Cameras, Lenses, and Flash 80

TODD JOYCE . 81

More Background . 81

Describe Your Studio 82

Your Specialties . 82

Getting Acquainted with Clients 83

Preparing Poses . 83

The Importance of Lighting 84

Using Props . 85

Discussing What You Are Doing 85

Facial Flaws and Excess Weight 85

Teen and Child Poses 86

Posing Groups . 87

Clothing for Portraits 87

Digital Alterations . 87

Body Language . 90

Cameras, Lenses, and Flash 91

LARRY PETERS . 92

About Your Background 93

About Your Studio . 93

Your Specialties . 94

Getting Acquainted with Clients 94

Preparing Poses . 96

First Portrait Poses . 96

Encouraging Improvisation 96

Inspiring Good Expressions 97

The Importance of Lighting 97

Using Props . 98

Discussing What You Are Doing 100

Facial Flaws and Excess Weight 100

Teen Portraits . 101

Posing Groups . 102

Clothing for Portraits 102

Digital Alterations . 103

Body Language . 103

Cameras, Lenses, and Flash 103

DAN HEFER . 104

More Background . 105

Describe Your Studio 106

Your Specialties . 106

Getting Acquainted with Clients 106

Preparing Poses . 108

First Portrait Poses . 109

Encouraging Improvisation 109

Inspiring Good Expressions 109

The Importance of Lighting and
 Camera Angles . 110

Using Props . 110

Discussing What You Are Doing 111

Facial Flaws and Excess Weight 111

Teen Poses . 112

Location Poses . 112

Posing Groups . 112

Executive Portraits . 113

Equipment and Backgrounds 113

Postproduction . 113

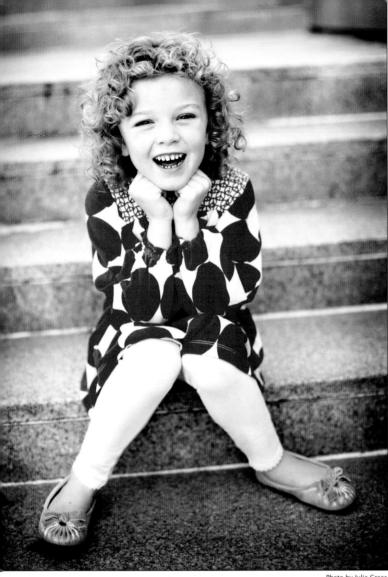

Photo by Julia Greer.

ANGELA STOTT 114
More Background 115
About Your Business 116
Your Specialties 117
Getting Acquainted with Clients 117
Preparing Poses 118
First Portrait Poses 120
Inspiring Expressions 120
The Importance of Lighting 120
Posing Young Children and Using Props 121
Discussing What You Are Doing 121
Facial Flaws and Excess Weight 121
Teen Poses . 122
Posing Groups . 122
Advice About Clothing, Etc. 123
Cameras, Lenses, and Flash 123
End Notes . 124

Conclusion . 125

Index . 126

ABOUT THE AUTHOR

Lou Jacobs Jr. says he's an industrial designer (Carnegie-Mellon University), turned photographer (Art Center College of Design), turned writer (the school of occasional rejections). He lived in Pittsburgh, PA, and eventually moved to Los Angeles, CA, where he took root. For many years he shot for magazines and went to New York frequently to visit editors. He was on the ASMP board for many years and is a Life Member. He took six months off to travel in Europe where he shot 35mm and used a 4x5 view camera for fine-art work.

After writing for various photographic magazines, Lou was asked to author his first book—about variable contrast papers. More books followed on numerous photographic subjects, plus sixteen other books for young readers on jumbo jets, transportation, the Watts towers (story written by Jon Madian), marine mammals, space exploration, and American landscapes. In various years he taught photojournalism at UCLA Extension and Brooks Institute in Santa Barbara. For two years he and his late wife (Barbara) lived and traveled in a motor home, crossing the United States and Canada four times. They wintered in Florida, and after returning to the West Coast they settled in Palm Springs, CA, where Lou built another darkroom that's now convenient for storage.

Lou and his current wife of twenty years, Kathy, spent many vacations towing a trailer to visit national parks and photogenic places from Maine, to Utah, to the Northwest. They told friends and relatives, "We bring our house to your house." The couple visited many European countries in rental cars in four different years. They loved many areas such as France and Venice and Salema, a village at the southern tip of Portugal on the Mediterranean where iron ore in the rock cliffs colors them bright orange. Now they often visit Joshua Tree National Park, which is an hour or so from home. "There is no limit to rock formations to photograph," Lou says.

Lou has written and illustrated 37 books on photographic subjects and continues to write for *Rangefinder* and for his favorite publisher, Craig Alesse at Amherst Media.

INTRODUCTION

POSING IS AN ART

Posing portraits is an art that takes skill and experience. It's also a challenge that requires tact, a keen sense of composition, and excellent shutter button reflexes. During a session, your subject moves almost continually between shots, and successful portraits depend on friendly rapport to signal "stop there." A photographer I know says you need empathy to think like the subject does and anticipate good portrait poses. Your kind of patience can inspire the subject to be patient, and you can share many creative moments. Posing is the basis of fine portraiture that you will meet and beat at every session.

All the ramifications of posing people in a studio or on location are discussed in these pages by ten experts whose pictures illustrate their words. You will find their images enlightening, and each chapter offers a lot of personal advice on how they tackle portrait problems. They also cover related business matters. Their combined viewpoints can help you shoot attractive, saleable portraits.

SMILES

Your portrait session may start out with head-and-shoulders poses and progress to full-length shots. You decide by instinct and according to the subject you

Photo by unknown photographer, late 19th Century.

are facing. Your suggestions tease smiles and sideways glances from subjects. You both get more involved. As you concentrate on facial expressions, you coax people to twist and turn their bodies. They may lean on a chair, touch heads, laugh out loud, and have a pleasant time because you help make the session fun. Posing eventually comes naturally to photographers because you understand what to say and do at the right times.

Smiles come in various shapes and sizes and are much preferred to scowls. Other expressions may be impish, flirtatious, somber, or just relaxed. Some are spontaneous, some you inspire. It's fulfilling to photograph faces with an inner glow that respond to your intentions. You know they will be pleased with their prints. Momentary smiles are your rewards, often ac-companied by meaningful glances or thoughtful relaxation. Straight faces also sell, because people want to look more serious at times.

BECOMING WISER

Clients are pleased to buy artistic and candid poses. A series of expressions preserved in pixels during a session will help you to create your gratifying career. You may be temporarily discouraged about expressions that got away, but hopefully you inspired the subject to repeat them. Your warm, persuasive approach and a little luck are a productive combination.

PREDICTIONS

Success and failure taught me a lot about posing various types of people. I discovered early on that lots of friendly direction helps clients look appealing. You will read ways of accomplishing this in various chapters along with other suggestions.

Some people pose naturally, others need verbal stimulation to help them relax and look lovely or cool. The only persons I've photographed who needed minimum guidance were movie and TV actors of both sexes, and a few politicians. They were photogenic and they knew how to successfully face a camera and seduce potential viewers. A few of my own images are included in this chapter.

LIGHTING

Skillful lighting adds greatly to making faces and figures appealing. But what you see in the finder doesn't always translate to prints. You shoot the right tilt of a head and a nice smile, and though the lighting seems pleasant, some frames are better than others. You can't expect to shoot just ten pictures and have each one saleable. We cajole men, women, and children, knowing that only some poses will be keepers. Most photographers shoot a lot of frames, varying with their personalities.

The more you practice lighting, the more popular your talent will become. As you learn varieties of the right light, beautiful lighting arrangements will please clients whose tastes will vary and may amaze you.

CONTRIBUTORS

The professionals who contributed to this book explain, among other things, what they say while directing people, what they look for when arranging lights, and how they work on location. They don't all agree on some topics, but differences of opinion help you discover more possibilities. Clients with different tastes will find your portraits attractive and satisfying, and the photographers whose work appears in these pages will acquaint you with their successful portrait techniques. Study the images that you find most attractive.

INFLUENCES

Review portraits in magazines and newspapers. When you see work you love, check the photographer's web site for added inspiration. (Go to Google, type in a photographer's name and state to find the pro's web

address.) In advertising photos, women are sometimes idealized beyond reality and men are handsome or rugged. To sell products and services or promote fashions, art directors may employ surreal and arbitrary poses. Maybe some will inspire you.

Editorial portraits in magazines, newspapers, and books usually try to reveal "authentic" people. Celebrity portraits may be cool and perhaps flippant. Media photographers try to devise interesting and dramatic poses in offbeat settings. Many editorial poses are intriguing, and while some won't suit your clientele, you may have opportunities to interpret others to make some clients pseudo stars. For instance, black backgrounds and blond girls make for an intriguing portrait recipe.

PORTRAIT POINTERS

- Personality is captured in your camera with smiles, gestures, angled faces, and lots of pleasant expressions. Your enthusiasm helps people unwind so you may shoot variations on their best poses.

- Shoot close-ups with a lens focal length between 75mm and 150mm, and fill the frame with your subject in some cases.
- You have opportunities to do character studies of some clients whose faces, figures, and clothing lend themselves to playing roles. Insightful poses, lighting arrangements, and your direction allow people to reveal themselves in successful and maybe surprising portraits.
- Think attitude. It can stimulate personality and may help generate worthy expressions. Words and music can pull attitude out of teenagers.

EXERCISES

If you are starting out in this business—or simply want to invigorate your existing business—offer potentially good models free sittings. (Some may be your friends and neighbors.) Tell them these are practice sessions and they are helping you stay up to date. Many will be delighted to pose in return for prints, and you are free to play with lighting and camera angles. Switch backgrounds and create some mood lighting. Test your flexibility in suitable outdoor settings. Find ready-made sets in front of shops, on church steps, in parks, or other locales that appeal to you.

You will have a different kind of good time shooting portraits for fun and games. Practice incongruity, such as using an old bridge as a background or by placing strangers next to each other and have them play momentary roles as gleeful friends. Take chances you wouldn't try with the average client.

Experimental posing is a refreshing way to boost your creativity, and it ensures a free and easy ambience as you shoot. Get excited when you see cool images. Ask someone, "Who are you really?" and be ready to shoot revelations. Praise inhibited subjects and be patient. You'll transfer some of your enthusiasm to paid sessions for sure.

GOING FORWARD

When I started this book, I took posing portraits somewhat for granted. Now, having thought about

the many ramifications of posing people who vary in appearance and attitudes, the advice and wisdom of the ten contributing photographers that follows is more meaningful. I think you will agree as you note their different backgrounds and the varying empha-sis they put on some phases of portrait photography. Each shows inspiring enthusiasm. You will learn as you share their words and pictures. I know I learned a lot.

Photo by Greg Lewis.

JULIA GREER
www.juliagreerphotography.com

Julia Greer of Marietta, GA, says she has been enchanted with portrait photography since she was nine. "I was intrigued with the idea of capturing reality rather than posed perfection," she says. She remembers photographing a friend and being disappointed by the forced, prim smile she captured in the images of her. Julia decided to keep the camera up to her eye, hoping her friend would let her guard down. Her friend led her to her brother's messy room, flung open the door, and giggled hysterically. "I caught the infectious, genuine expressions I wanted," Julia says. Julia took one darkroom class early on and later took photography courses in college.

ABOUT YOUR BACKGROUND

In my twenties, I bought my first SLR, a Nikon N90s, and it became a trusted friend during my travels. I bicycled through France, Austria, and several other countries in Europe and later Central America. My goal was to capture the spirit of places I visited, which usually meant opting for realism over intrusively posing people. I found that artisans or children at play were much more charming when they were going about their activities, rather than stopping what they were doing to flash a frozen smile at my camera.

I completed a photography course at Emory University in Atlanta and another at the New York Institute of Photography, but most of my style and techniques are self-taught. I've drawn inspiration from sources such as the Professional Photographers of America and the National Association of Professional Photographers, as well as from an online community of children's photographers. Renaissance-era oil paintings and contemporary editorial photography have also influenced me.

Before starting my photography business, my career was in marketing and business consultation. I earned an MBA degree, which has given me an in-depth knowledge of business marketing strategy, advertising, and public relations. I had the foundations that I needed to launch my portrait photography business.

DESCRIBE YOUR STUDIO

My 1600-square-foot studio is in the terrace level of my home in a lovely subdivision near the rural northwest of Atlanta. My location gives me easy access to farmlands, complete with wild grass fields and delightful old barns that are a photographer's dream. My immediate community is generally middle- to upper-middle-class, but adjacent communities are my more upscale target markets. I am about a 30 to 60-minute drive from areas in metro Atlanta where many clients live in surrounding upscale areas.

I have been in business since 2004 and have one employee who assists me administratively, but I do all the shooting in my low-volume studio or on location.

YOUR SPECIALTIES

I specialize in portraits of babies, children, high school seniors, and families. I accept commercial as-

signments on occasion but choose not to photograph weddings in order to focus on portraits. My studio is popular for photographing babies during their first year, though I shoot a majority of child sessions on location. For small children, I prefer to work at the client's home or a familiar park or other outdoor area. I love the natural textures and colors. I enjoy a variety of posing possibilities like old barns and urban streets. I gravitate toward locations that offer varying levels, such as steps, where I can easily pose individuals and groups.

GETTING ACQUAINTED WITH CLIENTS

My first goal is to bond with new clients and earn their trust. I want them to feel completely confident in me and to know that I genuinely want to capture their family's personalities. During the client consultation, I am likely to joke with them or coo over their little ones while I am going over session details. Many photographers, particularly one-person shops, make the mistake of going overboard to appear to be all business. Clients respond so much better when they can bond with their photographer, laugh with them, and see them as warm, "real" humans.

It follows that personality is a big asset in my portrait photography business, second only to the photography itself. If I am charming and engaging, it makes for a much more pleasant client experience. I challenge myself to find one obscure or bizarre thing that I have in common with the client. It could be

somewhere we've both visited, an out-of-the-ordinary style of music, a book we both love, or an odd experience we had in common. Once I hit upon that commonality, it's amazing how much warmer the interaction is. Even something as simple as congratulating a prospective client on their recent marriage or baby-to-be helps a client warm up to you.

FIRST PORTRAIT POSES

I typically shoot full-length poses, then get closer for three-quarter and head-and-shoulders shots. Full-length portraits are the most challenging, since the subjects are on full display. Once they are posed attractively for full-length portraits, they look great in close-ups as well. I try to begin with poses that make the subject feel most comfortable. Sometimes that means incorporating a prop such as a chair or toy. With adults and children three years and older, I frequently demonstrate first poses (and others later) so they know what I mean. I also keep images showing

various poses on hand as another way to enlighten my subjects.

A big posing challenge is having subjects look natural while they are beautifully posed. I can tweak hand and feet positions toward the light and tilt heads, but if the subject is wearing a frozen, unnatural grin, the portrait is a failure. To overcome this challenge I first pose the person attractively and then interact with them, joking and acting silly, so they smile naturally, and I catch great expressions. I will have couples kiss or cuddle or even get into a tickle war that produces a series of giggles and warm smiles that make good portraits.

I often find that my most awkward clients are husbands and wives. To overcome their initial stiffness, once I pose them attractively, I will ask them where they went on their first date, or who was attracted to whom first, or I'll tell the husband to give his wife an "outrageous kiss on the cheek." Their awkwardness melts away and I get warm, adoring looks between them, and usually some great smoochy shots as well.

ENCOURAGING IMPROVISATION

I absolutely encourage clients to improvise. One technique I use in nearly every session is what I call active posing. Like a movie director, I give subjects something to do. If it is a child, I may have him run through a field or cuddle with a giant stuffed bunny. I might have a family engage in a tickle war. If I am photographing a senior, I may have her play super-model. I capture the action and expressions as they happen. Kids and grownups enjoy loosening up.

INSPIRING GOOD POSES

As I've indicated, I tend to get my best expressions by simply conversing with my subjects. With young children, I might discuss animals as I make animal sounds, or their favorite cartoon characters. I might ask seniors if they have a boyfriend or girlfriend or what their favorite band is. For older children in the awkward "say cheese" phase, I give them strict instructions: "Do not smile. Whatever you do, keep a straight face. Don't you dare smile!" Needless to say, this usually guarantees wonderfully spontaneous smiles.

When I photograph families with young children, a favorite ploy is to have the entire family cry out, "Wheeeeee!" Something about that sound brings out facial exuberance in both children and parents in a ways the dreaded C-word can't do.

THE IMPORTANCE OF LIGHTING

Lighting, like composition, is critical to successful poses and creating beautiful portraits. I love classic lighting patterns (loop, Rembrandt, short, etc.) for most subjects. Carefully placed light and shadow emphasizes the lines and curves of faces and figures. For subjects with challenges such as skin blemishes, I often choose somewhat flat or butterfly lighting.

Shadows are as important as highlights in creating a mood. Shadows also wonderfully help to emphasize form, such as the figure of a pregnant woman. The more I want to emphasize form, the more dramatic the lighting and shadowing I choose. Lighting also helps create and sustain moods such as when a child looks pensive. Light augments the pose.

When lighting a group outdoors I use two to three strobes with modifiers to balance the natural light.

The key with groups is to have light falling attractively and fairly evenly on everyone's face, and I position my main lights accordingly.

USING PROPS

Furniture, other props, and even certain poses give seniors who tend to feel awkward in front of the camera the sense of being able to hide. Including their arms or hands can help them feel at ease. I often begin a senior session with the subject sitting on a backward-facing chair, with their chin on one hand. I give them positive verbal feedback about how great they are doing, and that boosts their confidence to try less safe poses without as much of a reliance on props. Toys are usually fine props for children.

DISCUSSING WHAT YOU ARE DOING

When I make a lighting or background adjustment, I usually mention what I'm doing, such as, "I'm changing our lights for a few moody shots," as opposed to "I'm adjusting the main light to produce a

rim lighting effect." Subjects tend to be more comfortable when they know what I'm doing along the way, and I keep them informed in terms they easily understand.

FACIAL FLAWS AND EXCESS WEIGHT

Shooting from a high angle is definitely the heavier client's best friend. I will either use a stepladder or stairs, or have the client sit low to the ground and face toward the lens to minimize a double chin. I use telephoto lenses to visually flatten prominent features and utilize shallow depth of field and flat lighting so blemishes are attractively obscured.

I find that most adults—even those who are virtually model-perfect—feel they have features they want to de-emphasize. I tell them about the flattering ways I'm photographing them and give them enthusiastic, positive verbal feedback to boost their confidence.

TEEN POSES

I always do a few classic senior poses. For example, I angle a senior girl's body away from the main light, with her face tilted toward the light. I also include more contemporary poses like those that fashion models use. Posing variety is important. Props, clothing changes, and scenery changes are also critical components of senior portrait sessions.

POSING YOUNG CHILDREN

Most children aged two or three and older can be given some posing guidance, even if it's as simple as, "How about if you sit in this chair? Look, it's just your size! Let's put your hands here," etc. With young children, I aim to capture movement and often provide toys, chairs, and props to guide them into appealing, natural poses. Depending on the age of the child, I will make crazy sounds or ask "Where did my piggy go?" as I balance a stuffed animal on my head. I also simply talk to them. When you ask a child about her favorite thing to do on a Saturday morning or her favorite toy, or even if her brother has stinky feet, the smile that lights up her face is sweeter than any on-command grin could be.

POSING GROUPS

The subtleties of composition contribute to the creation of an outstanding pose. The lines and forms in the subject's face and figure can become part of overall lovely arrangements. For group posing, I use the time-honored method of establishing compositional triangles. I want the triangular arrangement of faces positioned within the portrait. I avoid creating rigid rows in favor of a more fluid and natural composition, and I aim to make sure no two faces are on exactly the same horizontal plane when possible.

I like to photograph families in several different poses and compositions, usually starting with fairly traditional posing, then repositioning family members so they form a more interesting composition such as an S or C curve. It's important to show an emotional connection in a family portrait, so I try to link family members physically, such as having their arms attractively resting on each other.

CLOTHING FOR PORTRAITS

Clothing is critical to the overall success of a portrait. It's important that clothing colors and styles complement the subjects and the overall look and feel of the image. For instance, a dreamy portrait of a little girl in a field of wild grasses would be better executed with a muted cotton dress than a frilly outfit, and a contemporary senior portrait works well with vibrant, modern outfits as opposed to overly formal garb. I encourage clients to bring several changes of clothing, and I explain what will photograph best. We usually have time for at least one wardrobe change.

DIGITAL ALTERATIONS

I don't have an objection to converting backgrounds or creating digital composites, but I usually do not use them in my photography. However, I take full advantage of the magic of Photoshop. When photographing a large group, it's rare to capture an image with all members looking their best, so I often create composites (head swapping) so each person looks their very best.

BODY LANGUAGE

In terms of accenting strength or grace, for instance, classic portraiture requires different posing guidelines for male versus female clients. I tend to follow these guidelines when photographing families. I would never pose a father, for example, with a feminine head tilt. When photographing executives, I tend to pose both males and females in positions that communicate strength.

CAMERAS, LENSES, FLASH, AND BACKGROUNDS

I shoot with a Nikon D3 and a D200 and use a D90 as a backup. For outdoor portraits, my favorite lens is the 70–200mm f/2.8 VR, but I often use my 85mm f/1.8 as well. In the studio and in clients' homes, I most often use a 24–70mm f/2.8 and 50mm f/1.8.

I have eleven lenses for different effects, including a 12–24mm fisheye.

In the studio, I use three AlienBees strobes with Larson softboxes. On location, I most often use natural light, but I bring two Nikon SB-800 Speedlight flashes, plus Westcott Apollo softboxes for flash.

I have several custom-painted muslin and canvas backgrounds in the studio, such as a Les Brandt Old Masters and Background Artistry's Babycakes and Zachary backdrops.

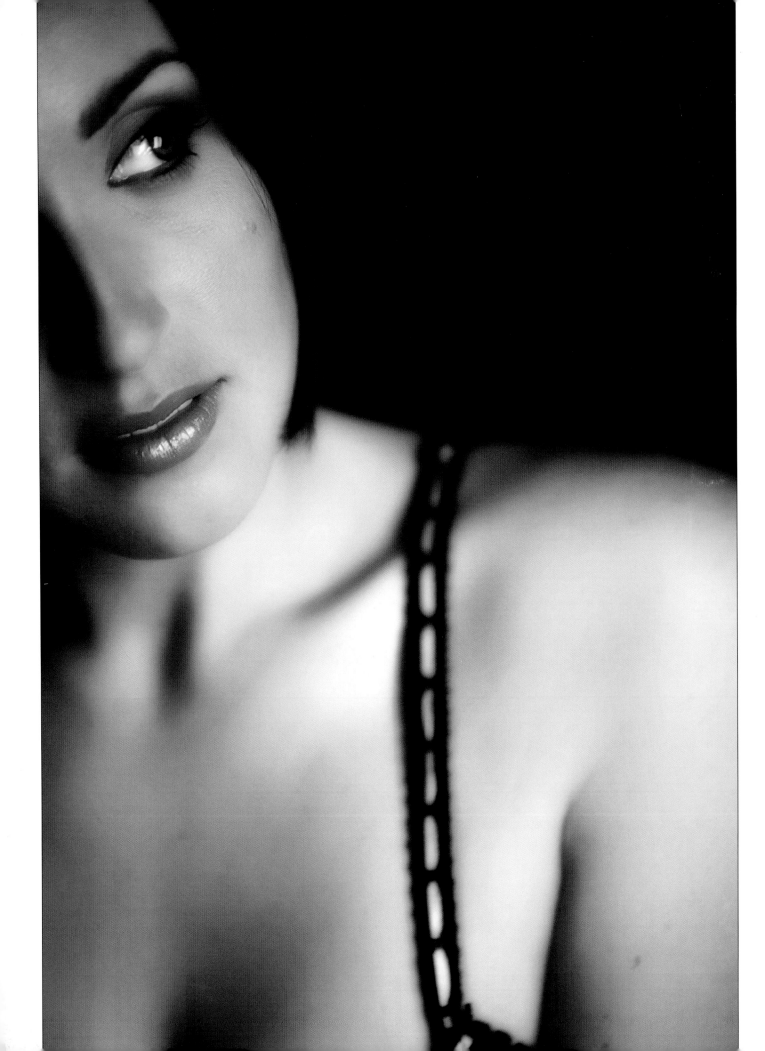

MARISSA BOUCHÉR

Marissa and her husband Weston are a team who own Bouchér Photography, a wedding and boudoir studio in San Diego, CA. The pair began as high school sweethearts in 1997 (they had the same high school photography teacher!) and now have two hairy "kids," Boston terriers. Their blog says, "Our passions and interests include our faith, travel, music, good books, nature, health/fitness, red wines, food, and global/local charitable organizations." The Bouchérs were voted Best Wedding Photographer in 2005 by their local ABC TV station. Marissa puts pictorial emphasis on photographing women in pinup poses that please their husbands. She has developed her own boudoir posing book, and this chapter includes her boudoir poses.

ABOUT YOUR BACKGROUND

I started in photography at Palomar College though I was shooting in high school at age of 17. Our business started on a small scale in 2001, and I taught myself techniques the best I could. I fell in love with photography and switched to digital in 2003, though I will always miss the darkroom. My husband is also partly self-taught.

In 2003, we were talked into shooting a wedding. We really enjoyed the experience, being newlyweds ourselves, and we began a full-time operation of Bouchér Photography. By 2006, I was ready to launch the boudoir portion of our business, Woman Captured. Kimberlee West and I shoot boudoir and she is my business partner for the Boudoir Divas. Under this name, we produce educational materials for other photographers. Kimberlee and I wrote a book about boudoir techniques in 2007. Woman Captured had unbelievable growth, and in 2008 we went from shooting in a small garage to using a 4500-square-foot studio in San Diego. Our materials

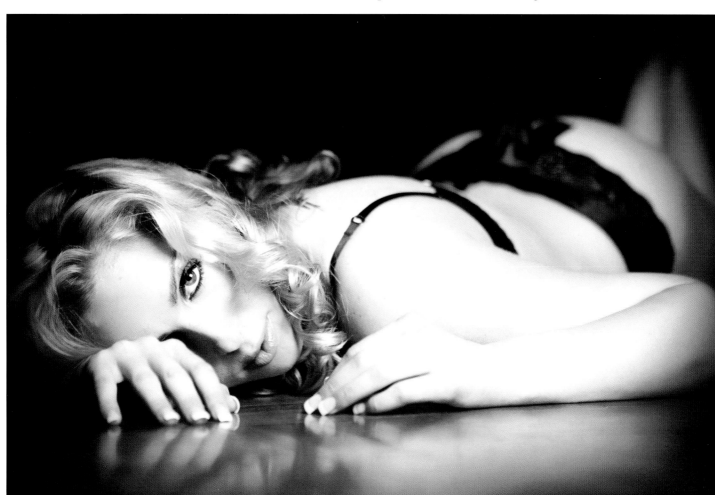

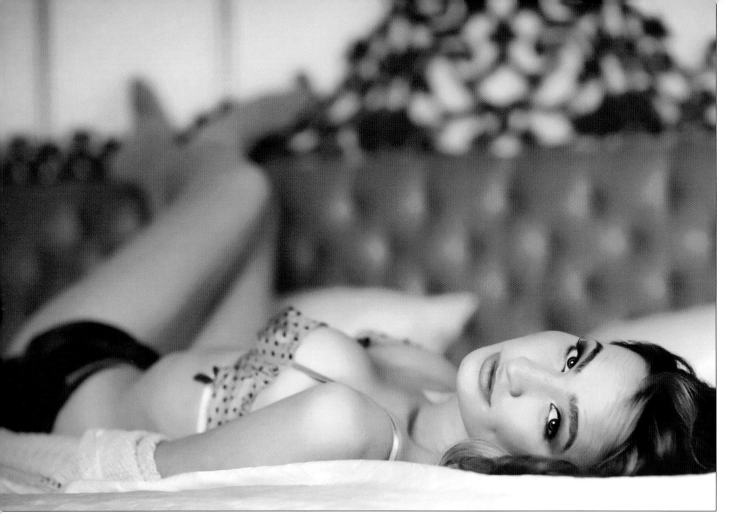

are available online at www.theboudoirdivas.com. We plan to release tutorial video footage in late 2009.

ABOUT YOUR STUDIO

Our studio is in a commercial warehouse where we have large framed canvas gallery wraps everywhere. We paid special attention to moody lighting and overall ambiance. Five of us work full time. I am the creative director, and I run the studio and do marketing. I also shoot our bigger boudoir packages. Weston shoots and manages the wedding portion of our business. I am his second shooter on weddings. Crystal Carr, our studio manager, is also a Woman Captured boudoir photographer. Our shooting space is about 1500 square feet. We have ten hand-designed boudoir sets, a few high-key areas, a dark and moody set, and a vintage bed with crown moldings on the wall behind it. There's a viewing and sales room for boudoir, and another for weddings, plus a 1000-square-foot production area, a break room, and a dressing room.

YOUR SPECIALTIES

Although my husband and I shoot weddings together, our studio specialty is definitely boudoir photography, where we spend about 70 percent of our time using the custom sets we created. In addition to the vintage bedroom and other sets we have a few outdoor locations available for a special fee. In 2008, we did about 120 sessions, and in 2009 we anticipate about 200. Boudoir denotes sexy, classy, "for his eyes only" photography. It allows a wife to give her hubby a gift that will add a little spark to the marriage. Our boudoir packages include an album and range from $560 to $1600.

GETTING ACQUAINTED WITH CLIENTS

Ours is a high-to-medium-volume studio, and we limit the time we spend with our clients. Once a client books her session, we send her a PDF that answers frequently asked questions and helps to prepare her for the shoot. This keeps her from having to e-mail or phone us. We also send a questionnaire that

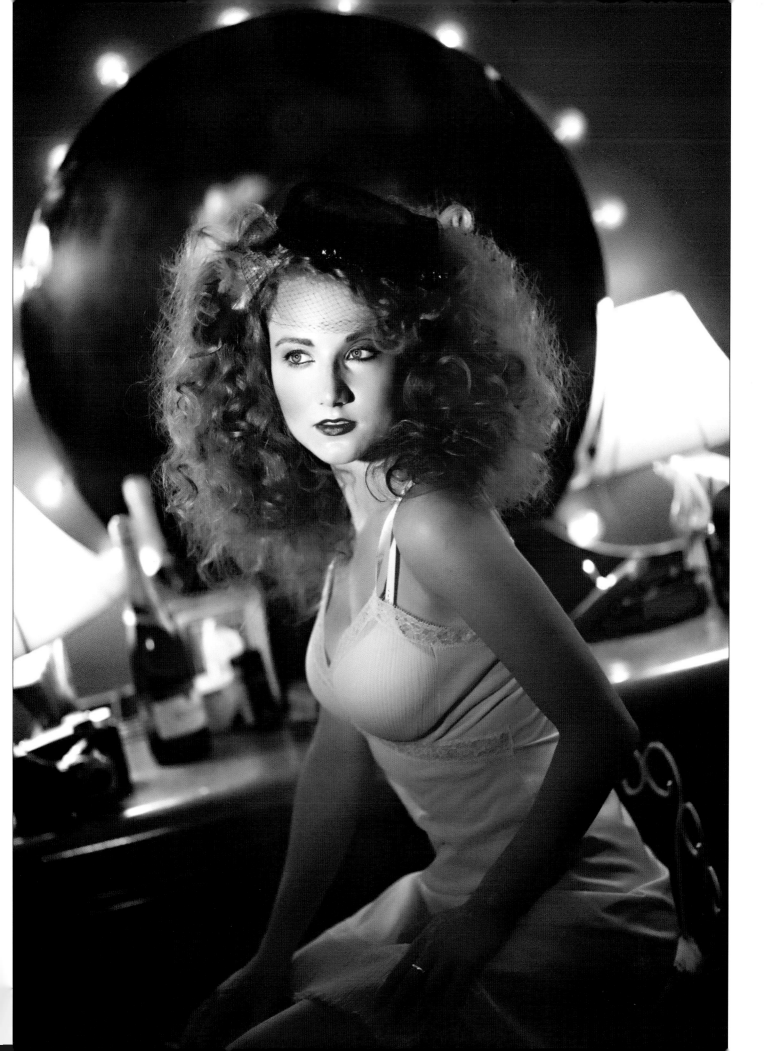

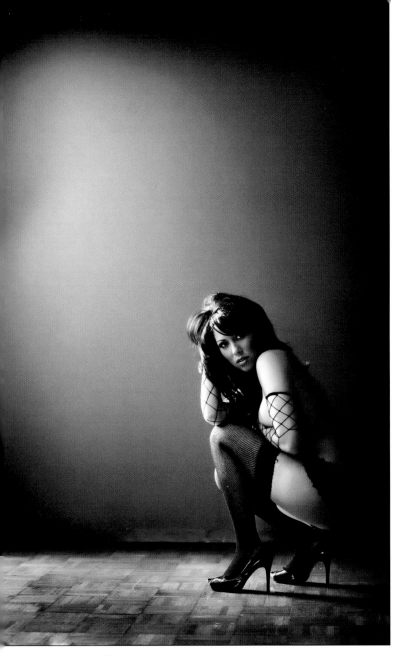

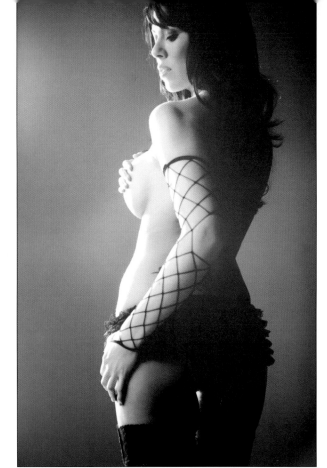

PREPARING POSES

We want our client to feel that she's in a safe environment where she can get outside her comfort zone. We are fun and friendly and avoid making her feel like she has to meet our photographic expectations. Our 14 poses range from lying down, sitting, standing, to different variations in between. Not having to think about what poses to do next allows me to create informal energy and a positive experience. I value a client's facial expressions even more than her poses.

In our boudoir marketing we put a great deal of emphasis on the experience. We want our client to enjoy the shoot so much that she leaves thinking, "Well, even if the photos are terrible, I had so much fun and it was worth every penny." But almost always, when the client sees the photos she just loves them, and it's icing on the cake.

FIRST PORTRAIT POSES

I always begin with the "Laura" pose, with the subject sitting on her side, usually on the floor on a cute rug or fabric. Her body is angled with her face in the

will help us determine what look the client is hoping to achieve, what she would like to accentuate about herself, and what she would prefer to hide. When women arrive in our studio, they typically understand the process. We chat a little more about her feelings and go over outfits and choose corresponding sets. This way, when we are chatting she doesn't need to bring up any self-perceived flaws that would create negative energy.

During the shoot itself, we get to know each other. However, boudoir posing can be very challenging. For that reason, we have memorized about 14 poses that flatter all body types, and we can really give the client the attention she deserves.

The Laura pose is so easy - and it is also an absolutely gorgeous pose on every body type! This is the pose we usually start out with first during a session, because it really is the perfect way to ease our client into the shoot. The biggest thing to remember with this pose is that your client's face/upper body needs to be closer to your lens (in the foreground), and her hips/legs need to be angled slightly towards the back of the room, away from your lens. Since most gals are a little more self-conscious about their hips and thighs, this trick will help minimize those things that she may be worried about. Keeping her legs in the background of your shot will make them appear slightly smaller, and if you're shooting with a wide open aperture, the focus of the shot will be her face and upper body, while her legs and hips are thrown out of focus.

Laura

During a session, we don't just shoot a few frames from one spot and then move on to a different pose. We are constantly moving around our subject, trying to find interesting angles. Every gal is different, and when it comes to posing, what works for one client might not be perfect for the next. With the Laura pose, you have endless ways to move and create new shots from different angles. You can shoot straight-on, then you can move slightly to one side and have her twist even more dramatically. Lastly, we always love to shoot from above. The Laura pose is one that is extremely flattering when shot from a high vantage point. The legs and hips virtually disappear, bringing the entire focus of the shot on the areas that women typcially feel more comfortable with.

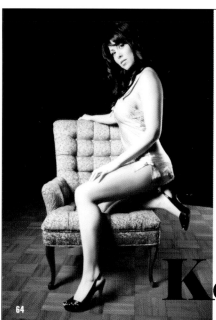

This is one of our top five most-requested poses. The Keely is a little more difficult than some, however, once you get used to coaching your client with this pose, we guarantee it will be one of your staples!

There are two different ways that we shoot this pose, depending on the gal's body type. For a slimmer body type, you can place the light at the front of your subject, lighting her straight-on. If, however, she is full-figured, she may be a little insecure about her tummy area. In this case, you will want to have your light pointing at her back, which will throw the tummy into shadow.

Just a few other tips for this pose:
1) Engage the leg on the floor in order to show definition in the calf muscles.
2) Have her keep her shoulders back, then exaggerate and arch (as always!)
3) Coach your client to take her gaze to various locations - straight at the lens, then also down and behind her, toward the floor, which makes for a very moody shot.

Keely

Melissa

One of our all-time favorites, this is a must-do pose with every single shoot. Have your client lie on her back at an angle, with her head and face closer to you - and her legs angled away. This is the best way to get that classic shot where she has her eyes closed - it shows off her eyelashes perfectly (see next page). There are so many different ways to shoot this pose, so be sure to move around and look for all of the different possibilities!

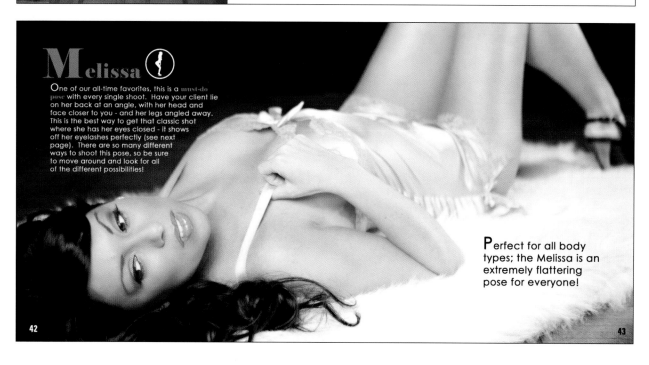

Perfect for all body types; the Melissa is an extremely flattering pose for everyone!

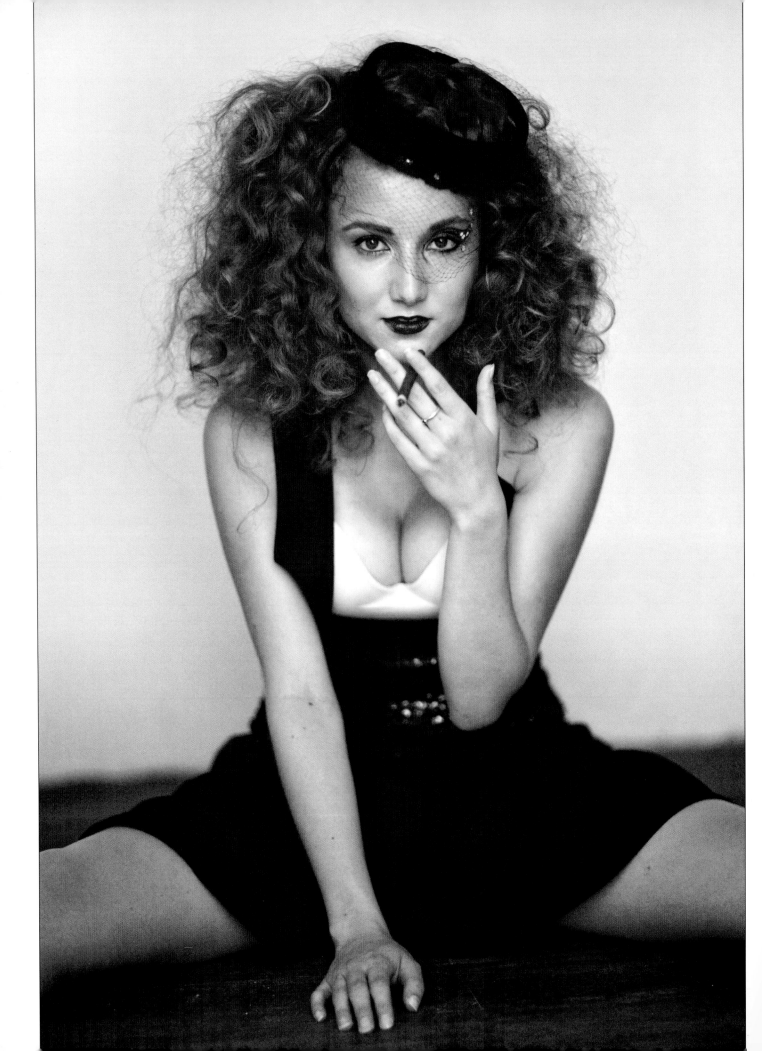

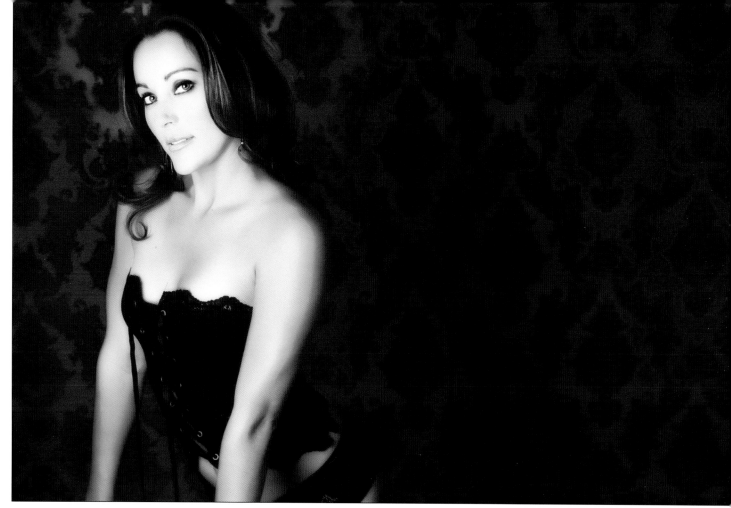

foreground and her legs in the background. It's a simple pose, and I usually demonstrate it first, which is much more effective than describing it. Since I am working with clients who are typically nervous in lingerie, I think they would shake in their boots if I asked them to improvise!

The more direction you can give with boudoir photography, the better. I'm aware that these ladies are nervous and will eat up any bit of instruction I offer. I think if I were photographing say, seniors, it would be my goal to get them amped up and comfortable to do their own thing. But with boudoir clients who you want to look their glamorous best from hair to toes, one must be a very detail-oriented photographer.

TRADITIONAL POSES

We photograph a variety of presentations and angles during each pose, including from just the eyes, lips, and upper body, to full length. We are always hoping our shots will have a bit of a fashion-forward look, so creative composition is very important. We observe our clients as much as possible to find their most flattering face and body angles. At least once or twice I try to put myself in a position that I would be least likely to choose to shoot from, and it's where I usually end up getting some of my favorite shots. I also like to take a few photos that show that we are in a studio.

FLATTERING POSES

Our "Laura" pose is one of our favorites for head-and-shoulders portraits, because it's extremely flattering for everyone. A number of our clients are fuller-figured women, and they often ask us to avoid their tummy area. To do that, we usually use our "Keely" pose, which shows off the entire body but highlights the back, and lingerie choices are very important. A longer corset that isn't too tight can be one of the most flattering choices on a full figure.

We don't do full-length shots too often because they are the most challenging to pull off for boudoir

clients. To create a great full-length boudoir photo, the client needs to be completely comfortable, and there needs to be movement to the photo as if she is walking, dancing, or showing off in some way. I am not certain why full-length boudoir photos of non-models tend to look a bit awkward, but unless your client has abundant confidence, I would just take a few full-length shots and make the majority of figure pictures more cropped.

USING PROPS

We do use a number of props. Vintage couches and chairs are a must for us at Woman Captured. Scarves and hats can also add a bit of movement to a stiff expression. We want our props to look real and not outdated, so we use vintage items that will remain hip and classy in the client's mind when she looks at her photos in years to come.

When we use a prop it is usually to show off a certain feature. Having a woman lean on a folded chair forces her to create a gorgeous arch in her back,

rounds her shoulders, and shows off her neck and décolletage. We also use a small vintage couch often. Having the client lie on her back seems to show off a woman's curves beautifully. This is a great way to keep the subject's hips a bit more blurred in the background since they are another self-proclaimed problem area. We also ask women to lie on their backs quite a bit, keeping her face sharp in the foreground.

DISCUSSING WHAT YOU ARE DOING

We never discuss the "why" of whatever we do with the lights, camera, etc. For example, I don't want the client to know that I am turning her body into the shadows to hide her tummy. It would upset her confidence. I want her to feel that she is a complete joy to photograph. Professional compliments are a must, and we never stop talking as we are shooting. If the photographer goes quiet, the client starts to wonder, "Am I doing the right thing?" We try to be expert and casual about inspiring confidence in boudoir clients, who may be nervous about posing.

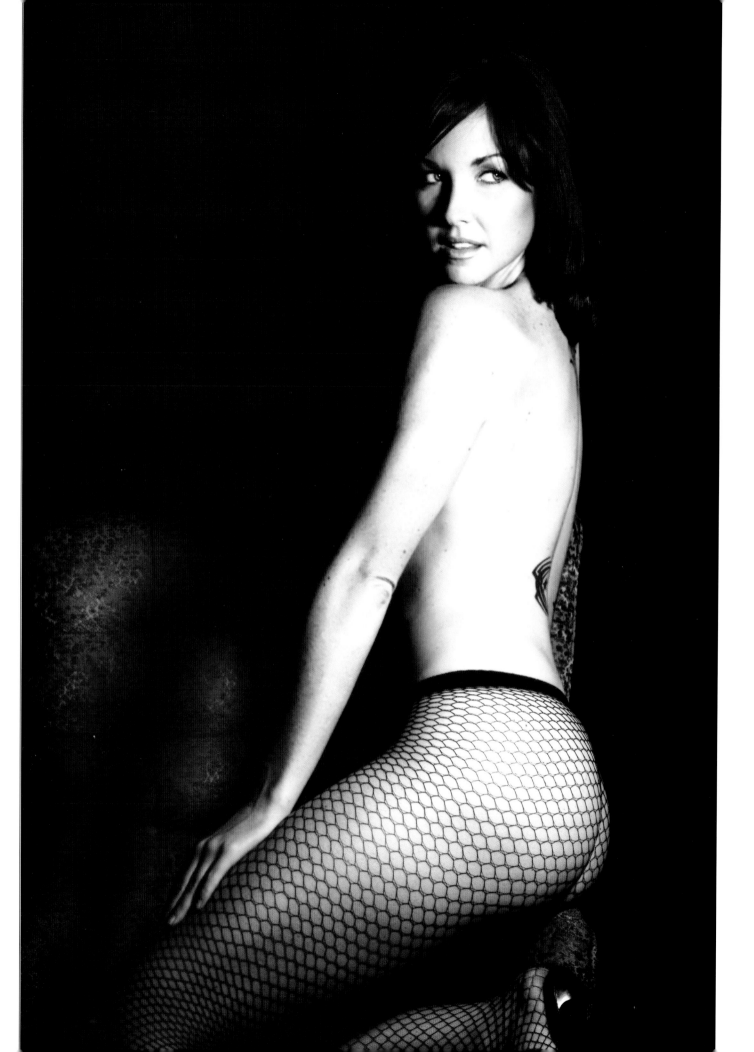

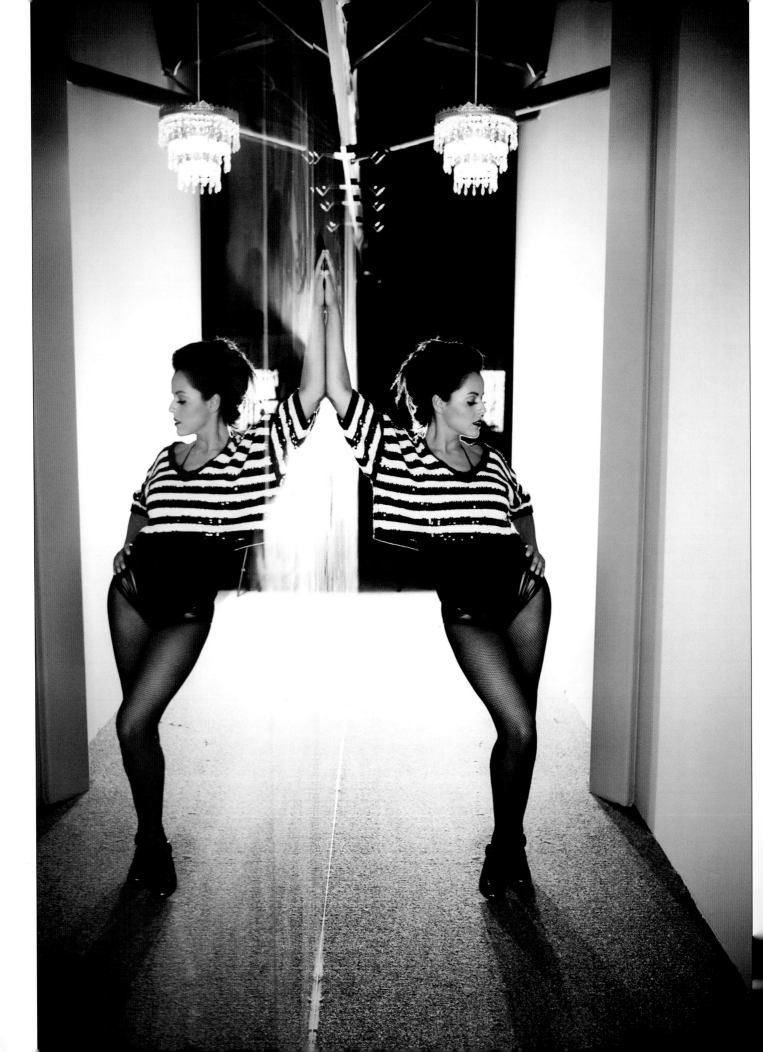

POSING GROUPS

We only have one client in the studio at a time, so we don't deal with posing groups. We do use a stepladder quite a bit to shoot down on individual clients to create a different and often glamorous angle.

PREPARATIONS AND PRICING

Clothing is very important to our boudoir sessions. We recommend that the client not wear anything too tight. We don't want her to be uncomfortable because something is pinching. We suggest things that are fun and playful to add interest to the photo. This and a lot more are included in the PDF we ask clients to read prior to their session. The document covers pricing, clothing, posing, etc.

Our sessions start at one hour on two sets with two outfits, and clients receive sixty proofs in a 5x5 book for $525. Packages progress up to 1.5 hours and more. We also have a package that includes picking a woman up at the San Diego airport, bringing her to the studio, doing the shoot, and returning her for a flight home. We promise "sexy and edgy photos," and there are numerous examples in the PDF to inform prospective clients about what to expect. Included might be advice about how shadows may make or break a pose and how we might look for open shade outdoors when it's appropriate, or light evenly in the studio.

For photographers who wish to offer similar services we sell a posing guide containing a lot of information about our boudoir program. You can find this at www.womancaptured.com.

THE IMPORTANCE OF LIGHTING

Our lighting setups are very simple. We were self-taught, so we really have to use our eyes to realize the best lighting on the subject, rather than be able to refer to traditional ratios or setups. With all of our lighting arrangements, we aim for fine pictorial quality. More than anything we want our lighting to look like the client is appearing in a classy fashion magazine where she looks drop-dead gorgeous. We use large softboxes and reflectors to put emphasis on the face and chest while trying to minimize the tummy and hips. There have been times when I have used a video light as a spot on a woman's face along with the softbox flash. Hot light seems to really clean up the skin and do away with any lingering shadows. When lighting boudoir clients, I look for falloff or shadows on the body, plus full even light on the face, which makes this technique come in handy.

BACKGROUNDS

Boudoir is the only type of portraiture that we do, so our studio is set up almost entirely for it except for a wedding photography sales area. We have ten hand-designed boudoir sets in the studio always ready for use. We arranged space for a variety of environments, and even when we were shooting in a small garage we still had six different sets, created by hanging fabric on a line we could pull back and forth when we wanted a certain look. Magazine references and a trip through IKEA or Home Depot have proven to be our biggest inspiration when it comes to devising top-notch sets.

CAMERAS, LENSES, AND FLASH

We use Canon 5D Mark II cameras. I find that our 50mm f/1.4 or our 85mm f/1.2 are most flattering on faces and figures. However, when I used to shoot in tighter spaces it seemed that the 28–70mm was the most useful.

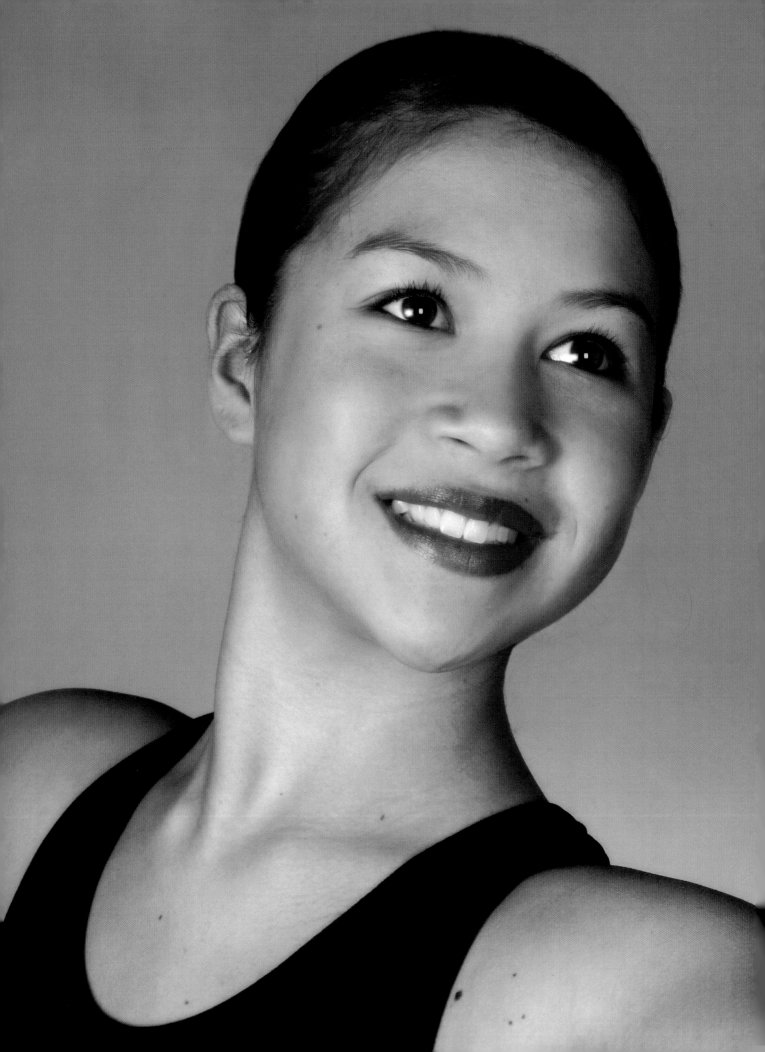

CAROLYN WRIGHT

www.thephotostudio.com

Carolyn Wright is a veteran Santa Fe, NM, photographer who earned a BFA from Alfred University in 1978 and worked for Nathan and Mary Shanks at Silver Springs Studios in Silver Springs, MD, as an assistant. She learned a lot from the owner and his wife about portraiture and the studio business. In 1981, she moved to Santa Fe, worked at a camera shop, and began offering black & white services through the store. She assisted and shot jobs the pros didn't want and soon freelanced full time. In 1985, she partnered with Eva Benavidez in her established portrait studio. Carolyn has owned the studio since Eva retired in 1994.

DESCRIBE YOUR STUDIO

My studio occupies 800 square feet attached to my home. I'm now established, and clients are willing to drive the extra few miles out of the city. I also have a complete portable portrait setup for house calls. I have an office assistant, a bookkeeper, and I hire a photographer to cover some events or assist me. I'm very particular about anyone I hire, and I train them extensively in my style and techniques.

Santa Fe is a market where wealthy globetrotters have part-time homes. Some families have lived here for centuries. The population also includes a classic

middle class, and our galleries are numerous. There are numerous Native American pueblos nearby.

YOUR SPECIALTY

My specialty is definitely people photography. I shoot in the studio, in scenic areas, in offices, homes, and resorts. I sometimes walk with my clients, shooting "Santa Fe style" portraits using the adobe architecture, native plants, and coyote fences as atmosphere. In the studio, I offer fifty background images shot in this area.

I photograph executives, families, graduates, children, weddings, and conventions. I've been hooked on computers since the late 1970s, and the "anything's possible" feeling I get with digital photography is exciting.

GETTING ACQUAINTED WITH CLIENTS

Communicating well and developing rapport with clients may be the most important steps in a portrait session. I try to sound easy to work with on the phone, and once an appointment is booked I discuss the purpose of their photos (e.g., does the client need business head shots, family photos, etc.?). We also go over clothing options and settings. Whether in the studio or at a photo site, I try to be warm and relaxed and make the whole experience pleasant.

In the studio I chat about the client's work, family, or local events. I spend time getting to know children. Sometimes I show them my equipment and let them make the lights flash. My personality is definitely a huge asset to my business.

PREPARING POSES

The purpose of posing is to make a subject appear natural in an unnatural camera room. My first boss taught me to observe how people stand, sit, and carry themselves. I learned body language and how people can look confident, alluring, or relaxed. When someone stands awkwardly in front of my camera, I talk them into a natural pose.

Some people want to pose themselves. I suggest we try a few shots their way, and then let me direct them for a few more shots when I understand what they're looking for. This always works, and invariably they choose shots that I posed.

I use little tricks, like having a person with a double chin slightly extend their head ("like a turtle" I tell them) to tighten everything up, or I suggest they sit up and slightly tilt toward the camera for a subtle aura of confidence. I often demonstrate poses, and with a comfortable subject, I use gentle physical direction of the head or hands. I look for tension such as hunched shoulders or elbows held rigidly. When I tell people what muscles to relax, they are surprised that they tightened up, and they relax.

A key is to never sound annoyed and act as if your client is posing normally all the time. It's okay to say nonchalantly that a pose isn't working, and try something else. I may suggest that we "play around a little," and their eyes light up about trying something new. When they see the proofs they are pleased that their poses are "unique."

FIRST PORTRAIT POSES

The purpose of a portrait often dictates whether it should be head and shoulders, three-quarters, or full length. A head and shoulders approach may connote a small image. In many advertising situations, a three-quarter or full length is specifically requested and often other specific poses are required. I almost always do groups in three-quarter or full-length poses. For graduates and children, I usually do a variety of head-and-shoulders, three-quarter, and full-length poses to really capture them, and I may also use props with teens and kids.

With head-and-shoulders poses, I may include hands, and I shoot a big smile, small smile, and serious look from various camera angles. Usually the feet are not important, and the face is larger in the final image. I may seat people in casual poses on the floor or on props. The larger the prints will be, the farther back the camera must be to create a comfortable viewing distance. In a 24x30-inch print a huge face can be inappropriate on a wall at home. For 5x7-inch prints on a desk, a full-face or head-and-shoulders pose suit the normal viewing distance.

IMPROVISATION

I find most people are unable to be spontaneous and look graceful as well. Small children are an exception,

and you can get great shots just letting them play. They can't be rushed. They need time to get used to you and the surroundings, but once they are comfortable they can surprise you with wonderful expressions.

INSPIRING GOOD EXPRESSIONS

The best way to get smiles from most people is to be very friendly and outgoing and talk about things important to them. I banter just before I click the shutter to gets smiles when the client is relaxed. My banter lines include, "Turn on the charm" and "This is the most fun you'll have all week." Find words and phrases that work for you. Some people, especially teens, try smiles but may look odd and plastic. Many people don't want to show their teeth, and ironically, they may be those with the brightest smiles. I talk very frankly with these people and urge them to feel like smiling. I explain that we're not used to seeing ourselves smiling, even though friends and family think we look great.

Sometimes I tell people to imagine they are greeting their spouse or parents. Or I suggest they just bought the winning hundred-million-dollar lottery ticket! With family groups involving small children I tell the adults to look at the camera and be ready, then act completely ridiculous playing peekaboo, whistling, or fake sneezing, and usually the kids and adults put on happy faces. My first boss told me, "You can't be a people photographer if you're afraid of looking silly."

THE IMPORTANCE OF LIGHTING

Lighting is crucial to portrait posing. Study a subject's face and body and decide if you want to minimize anything, and set lights accordingly. If a person has a long nose, create a short shadow under it or diffuse the lights. For heavy people, avoid flat lighting, which will make them look extra wide. For groups, lift the lights to avoid having the shadows of the people in the front cast on those behind them. Take care that props are lighted discreetly. Outdoors, balance

flash with natural light to open shadows but not overpower the daylight.

I use an adobe wall to reflect warm light on portrait subjects. You usually want lighting to be soft, unless you are emphasizing texture. Lighting can create moody images if that is your goal. Artists, musicians, and performers love moody and dramatic portraits created through posing and lighting.

USING PROPS

Props may make people more comfortable and less self-conscious. Props can also aid composition by creating places for hands to rest or people to sit. Chairs, stools, pillars, walls, fabrics, flowers, and so forth can, with the right lighting, help create a variety of portrait looks. Some props—sports equipment, musical instruments, art tools, books, even cars and motor-

cycles—can help tell a story. They work especially well with teens. Such props enhance a pose and help illustrate who a person is.

DISCUSSING WHAT YOU ARE DOING

I talk all the time during a session to make the subject feel at ease. I tell them I will be posing them in a number of shots, which they can see right away on a computer monitor. I remind them that the finished pictures will be retouched and enhanced. I explain that the lights will flash, but they shouldn't move right away so we can get variations. I always show the first shots I take, and usually people are pleasantly surprised and they relax. When they don't like their hair or clothing, we fix it right away. If they are critical of the composition or pose, I try to incorporate their ideas or explain how we can create alternatives.

After a few more shots, when we're on the same page, we proceed without looking at each shot. By then the client is usually comfortable and the session winds up a success.

FACIAL FLAWS AND EXCESS WEIGHT

We can be our own worst critics, so minimizing flaws is important to clients. The exceptions are persons who are comfortable with the way they appear in photos. However, clients may feel they have crooked smiles, one eye smaller than the other, round cheeks, tummy rolls, etc. Anything I can do to minimize these "imperfections" is greatly appreciated, and Photoshop can help to remove double chins, shorten noses, elongate chains, whiten teeth, open eyes, slim waistlines, and so forth. Subtle touches are enough to make someone feel that's really what they look like at their best.

Heavy people can be posed with another person or a prop blocking part of their body. Alternatively,

you can do only head-and-shoulders shots, shooting from a slightly higher camera angle. Avoid big smiles, which widen the face. Shoot slightly up at long noses or down at weak chins. Soft, close lighting helps min imize wrinkles, and frontal lighting widens a thin face. Experiment with turning and tilting heads to straighten noses.

TEEN POSES

Teens are usually less formal than adults, and they tend to want more poses. They like clothing and background changes, and props they bring or I have on hand (flowers, pillars, ladders, fabrics, numbers, chairs, benches, stools, and more). With whatever teens bring, I try to create a variety of mood poses from different camera angles and from head-and-shoulders shots to full-length poses. I do simple poses like leaning against a wall or sitting on the floor, or use full sets with painted backgrounds, furniture, and flooring. I continually try to capture a senior's personality and let poses and props enhance it. I talk with teens and ask about specific poses they've seen and we duplicate them.

POSING YOUNG CHILDREN

I have worked with two- and three-year-olds who were able to follow directions. I've also worked with children as old as nine or ten who had difficulties. Talk to children before the session and get a sense of how much direction they may take. Young children's natural grace may offer delightful expressions and poses. Start simply, and when they're involved expect some great poses.

If a child can't follow directions or sit still, I often place soft lighting over a broad area of seamless backdrop and let the child interact with me or others (usually off camera) and with toys, props, and maybe pets. You can't rush children or persuade them when they're not in the mood. Stop for snacks.

POSING GROUPS

Smaller groups offer more posing options. People can stand or can be seated on props. They may recline on

the floor. In a home, I use sofas, chairs, stairs, and other posing platforms. In offices, I use desks, chairs, walls, railings, and office machines as posing aids. Outdoors I pose people on walls, rocks, against trees or fences, or in the grass. I vary heights in a group and have the subjects' shoulders touching gently. With more than six or seven subjects in a group, it's harder to be creative. Use whatever props are available for variations.

Keep the lighting high and flat without shadows on people in the back rows. For larger groups, I shoot from a ladder, chair, or stool. With a really large group, consider shooting from a second story window or a balcony, with everyone looking up.

CLOTHING FOR PORTRAITS

Casual images usually require casual clothing. Before the shoot I talk to subjects about what to wear, especially for business portraits. Clothing can make a statement about who the person is. I may recommend wearing fall type clothing for most family or individual portraits. Long sleeves prevent showing a break in the arm line. Muted colors allow faces to stand out better. I caution people against distracting, wild patterns and large reflective jewelry.

I suggest that groups decide on a set of colors and shades that go together in casual clothes or business attire. In some situations try to bracket the bright, lighter colors with the darker, more muted ones. I encourage clients to bring changes of clothing, and if we shoot in more than one outfit, clients often order prints with each outfit.

DIGITAL ALTERATIONS

Santa Fe has many beautiful scenic areas, and tourists may want portraits against classic backgrounds, so I have a collection of scenic backgrounds. I photograph clients against a neutral studio background, which will be supplanted by the scenic of their choice. Make sure lighting in the studio matches outdoor lighting, and avoid contrasty scenic lighting. It is much easier to take head-and-shoulders or three-quarter portraits and drop in the background than it is with full-length shots, which usually require added ground shadows.

BODY LANGUAGE

The main way to say something about subjects is through body language. The way people sit, stand, tilt their heads, and use their hands speaks volumes about them. Someone posed in an atypical attitude will make a portrait look artificial. A business pose and expression need to tell the world the person looks confident, capable, and easy to work with. For example, a psychologist or a counselor may want a much softer, warmer pose and expression than a trial lawyer.

Posing symbolism is subjective. A head tilted toward the upper shoulder is submissive; a head in line with the midpoint of the body is strong. Arms folded across the chest hint at insecurity, whereas arms to the side and hands on hips convey confidence. A face turned slightly to the side can create an air of mystery. Watch people in natural settings and notice how they carry themselves.

CAMERAS, LENSES, AND FLASH

I use Fuji S3 cameras with Nikon lenses, and I've been drooling over the S5s. My favorite lens is an AF Nikkor 24–120mm zoom. In the studio I have a Speedotron strobe system hanging from a ceiling mount, plus a duplicate Speedotron system with light stands for use on location. I use softboxes with an extra diffuser panel and umbrellas when I am shooting on location. I have a couple of slave strobes, and many different size foam core reflectors. On camera, I use a Metz handheld flash on an adjustable bracket to position flash above the camera.

ELIZABETH ETIENNE

www.eephoto.com

Elizabeth photographs weddings, engagements, pregnancies, individual portraits, and newborns on location and in her studio in Marina del Rey, CA. In her twenty years as a professional she has traveled to Europe, Hawaii, and Mexico, and she lived in France for seven years. Her first boyfriend in high school was in a band, so Elizabeth took a photography class, got hooked, and began selling band photos. She went on to study at Brooks Institute in Santa Barbara, CA. She says, "I was drawn to portrait photography because it seemed a very real, intimate, and authentic way of documenting life."

ABOUT YOUR BACKGROUND

My influences covered a diverse range from Annie Liebovitz to Robert Doisneau. Liebovitz has a great talent to create eccentric, intimate, quirky celebrity portraits. Her poses and compositions were refreshing when I was in my twenties. She was also among the first female photographers to gain such prestige. Robert Doisneau's timeless images of people and life in Paris captivated me, perhaps because of my French heritage, my love of all things antique, and my hopelessly romantic heart.

When I graduated from Brooks, few assisting jobs with established photographers were offered to women, and I realized I would have to start shooting on my own. Fortunately, my first commissioned photo job came almost immediately, a portrait of a film industry executive for a monthly film location magazine.

In 1990, on a trip to Paris, I was again lucky to land a job shooting album covers of French pop singers for the record industry. I had lived in the Alps for a year prior to starting my studies at Brooks, and I decided to move back to France again. For the next several years, I continued shooting portraits of lovers, friends, and life in Paris, and by the time I returned to California in 1998 I had developed my trademark style of imagery.

DESCRIBE YOUR STUDIO

My studio is the beach area in front of my home office. Living in southern California, I can take advantage of the mild climate and natural beauty outside my front door, so I shoot primarily in an exterior environment. Occasionally I use a studio or interior location if the job calls for it, but my preference is shooting outdoors. My employees are all independent contractors.

My specialties are theme-oriented weddings and engagement sessions, pregnancy, babies, individual and family portraits, advertising, stock, and fine art. Many of my commissioned portraits become recycled into stock images or fine art. I love exterior locations that give me a variety of natural elements or beautiful architectural surroundings. When photographing groups, I usually look for a natural environment like a park where I can place the group under a tree in flat light and use the leafy branches as a frame.

GETTING ACQUAINTED WITH CLIENTS

I break the ice gently by allowing clients to ask me questions, because people want to be listened to. My personality plays a huge part in initial meetings. I take pleasure in expressing my photographic ideas for clients boldly and passionately, and they are apt to seal the deal due to my attitude as much as my images.

I never ask personal questions unless there is an obvious invitation. I avoid the possibility of making anyone feel interrogated, which can turn people off. I do love it when they open up to me. There is a fine balance between being personable and friendly and keeping your attitude professional.

PREPARING POSES FOR A SHOOT

Being photographed can make many people feel uncomfortable and even vulnerable, so I gently guide them into a pose by suggesting, "Stand like this or that." I pretend to look away and they will relax and their pose will fall into a more authentic, organic place. Then I'll nonchalantly click the shutter. It's my pose, rest, shoot scenario.

I'm known for my stylized, theme-oriented couple's engagement sessions, a collaboration that takes weeks to prepare. We begin by reviewing images in portfolio books and web sites, and we mark those we like. Sometimes I'll save magazine images for posing, wardrobe, hair and makeup, and composition references. Other times, we'll come up with totally new ideas. Either way, I try to put a personal twist on a theme for a each couple. Once these ideas are in

place, I'll begin to scout for the right locations with natural light. We then build a preproduction folder for each couple. Having an image reference and shoot list to work with is the best way to guarantee you'll have something to guide you through the photo session.

My contemporary engagement images are all about the couple's natural chemistry and personality together. They may be playful or more serious and intimate. I try to pick up on their vibes and gracefully direct them into poses. I am aware of how my mood can also affect the feeling of a shoot. The chemistry between the photographer and subject becomes apparent and plays a big part. My specific shot list is only a reference, and there are always new discoveries. The unexpected is fun and challenging.

I recall a very shy couple who appeared as though they were not used to displaying their affection in pubic. I later learned their culture did not like to see couples too intimate until after they were married. They were sweet, tender, and very special, and I respected their boundaries and didn't push them. Another couple seemed willing to do just about anything I suggested. They were both surfers, so I suggested they lay down in the ocean tides and I just let them go! They loved it, and I just kept clicking the shutter button.

BEGINNING PORTRAIT POSES

I typically begin by shooting from farther away and move in for close-ups. This seems to be a natural, human progression in a relationship. Of course, with closer shots, I pay more attention to details of lighting, posing, and composition. To encourage the right expressions, I typically pose a person first and then make a comment or two to let them react. If I'm searching for a funny, light, or happy expression I might crack a joke, from the sarcastic side of my per-

sonality. While some people need less direction than others, ultimately it's my job as the director to guide them into one pose or another.

With kids, I might tease them or give them a tickle. If I am looking for something more serious, like with couples, I'll simply place their heads together or have them close their eyes and dream about their favorite vacation together or the first time they kissed. It's important to just relax, take a deep breath before making exposures, and allow the person to just *be*. I rarely force an expression.

I love capturing details. Hands and feet are an important part of posing too. They add a more intimate look in relationships. To soften skin, I will sometimes use a soft-focus filter and/or shoot wide open (i.e., f/2.8), and shift away from problem skin areas.

THE IMPORTANCE OF LIGHTING

Lighting is very important to posing. If a person has a heavy face, I will often place one side in shadow and focus primarily on the eyes. I backlight most of my close-up portraits to create a moody, sensuous, more romantic feel. Depending on the look I am trying to achieve, I may use side or split lighting, silhouette

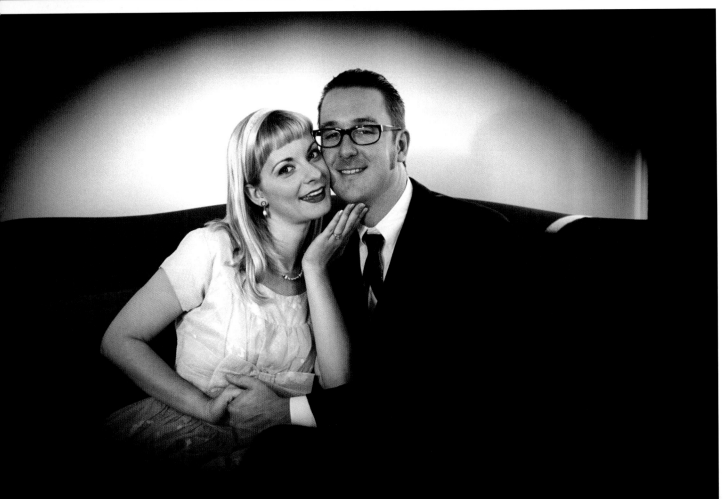

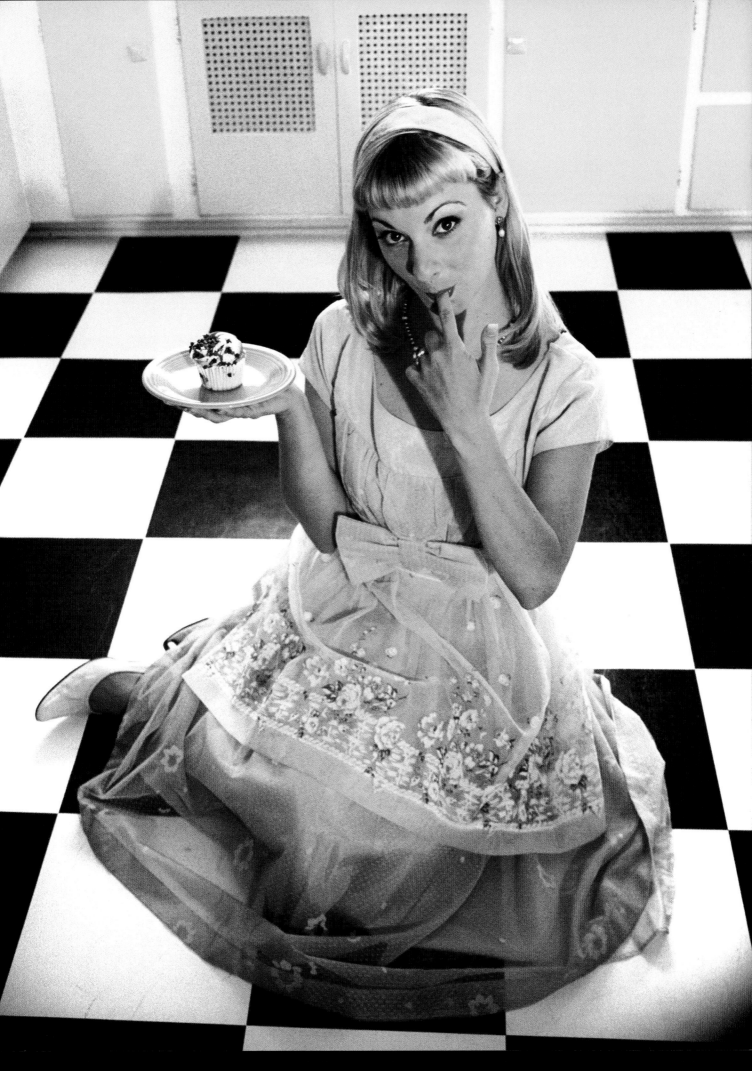

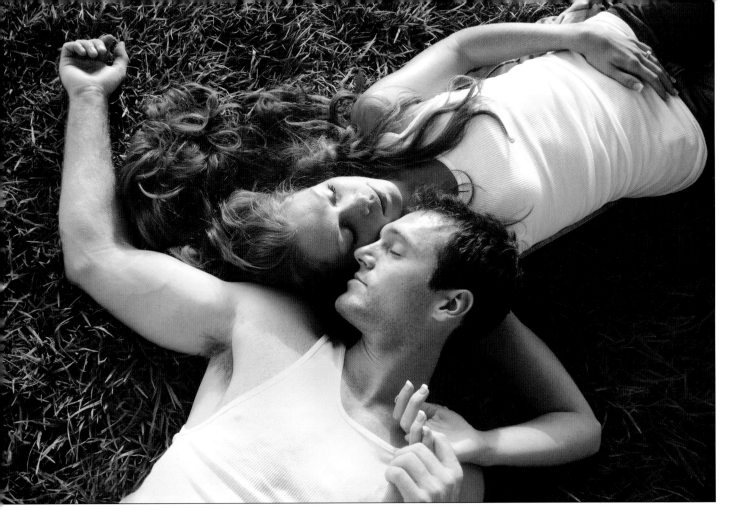

lighting, flat diffused lighting, dappled or patterned lighting, or rim lighting. Lighting is the photographer's voice. Adjusting the light one way or another can drastically change the look and feel of an image. Subtle changes are often called for.

I live in an ideal climate, so I shoot primarily with natural light assisted occasionally by a reflector panel or fill flash from a mini softbox. I find that my subjects are more comfortable posing outdoors than in a studio, because they don't feel intimidated by the equipment. The result is more natural, and that's what I'm after. I love the variety and challenges of outdoor settings, and my clients have more fun.

USING PROPS

I use few props, but prior to a group session, I ask my clients if there will be any physically challenged individuals (i.e., elderly or handicapped persons). If so, I make sure there is something for them to sit or lean on, and I try to pose the groups around this person in the most natural way. I keep a folding chair in

my car just in case. Giving a senior an activity to do always makes them feel better and allows their personality to show through.

DISCUSSING WHAT YOU ARE DOING

I occasionally talk to clients about what I am doing. It helps them feel like they are a part of the creative process, gives me something to discuss while I'm preparing my gear, and makes them feel more confident in my abilities. I might say something like, "This gold reflector is amazing. Its makes your skin tones glow and illuminates your eyes. You look great!" They immediately relax, trust me, and let go.

FACIAL FLAWS AND EXCESS WEIGHT

Lighting and posing are key when it comes to successfully photographing overweight people. To slenderize subjects, I look for outdoor shadows. I try to slim the subject by suggesting they stand sideways, placing their heavy front section in the shade, or behind a tree trunk or wall. If it's a couple, I always

place the slimmer person in front to block half of the heavier person. I photograph a heavy-faced person from a slightly higher camera angle to minimize a double chin. I also carry a small black foam core card to create a shadow on a heavier face and sometimes use a hand mirror to illuminate only the central area of a face.

POSING OLDER PEOPLE

Older clients may be less flexible than other adults when their mobility is limited. Also, some may have stood or posed in certain ways for many years. It's our job to recognize these poses and try to encourage something more natural and spontaneous. Having a grandchild around always works well because grandparents happily loosen up. I will often ask grandchild to sit in with grandma and grandpa for poses initially, which seems to take the edge off.

POSING YOUNG CHILDREN

Kids are challenging, and you don't know quite what you'll get, but this can work to your advantage. It's important to politely ask parents to step aside during the session as they may distract the child while you're trying to establish a connection. Some kids are less cooperative than others, but this can create the best spontaneous candids, so don't put your camera down as you're encouraging a child's pose.

One of my most successful stock images happened when the family's dog jumped on the bed and woke up a little boy by licking his face! I just kept shooting, and the images were fun. Animals, other kids, familiar toys, and treats also make great sidekicks.

POSING GROUPS

When preparing to shoot large groups I look for a staircase, a sloped hillside, or an elevated place to shoot from. I'll begin with slightly traditional poses but then suggest something fun for them to do to help them connect and generate candid reactions. Sometimes it's my buddy bonding, arms-around-each-other-huddle. Other times, I use a prop. I may also try a V-shaped arrangement for variety.

When I anticipated rain during a wedding shoot, I had my assistants buy a bunch of cheap umbrellas. I calmed the nerves of the frantic groom by reminding him to think about *Mary Poppins* or the classic film *Singing in the Rain*. He laughed, and the tension broke. Not only did the groomsmen have fun jumping in the air (imitating Poppins), but we turned what could have been a frantic episode into a successful shot.

CLOTHING FOR PHOTOS

The wrong clothes can destroy a great shot, and trendy clothes can date an image. Unless I'm intentionally shooting a stylized vintage session I'll often suggest classic, timeless, simple clothing. It's important also to consider a subject's personality and body type. Bright, colorful prints don't work well on heavy people but can be cute for kids. Black can be slimming, and white can give an angelic, romantic appearance, but the photographer needs to watch the contrast ratio so that detail isn't lost in black and white areas.

I like photographing couples in matching attire. For some engagement images and family portraits I suggested simple his-and-hers white tank tops. I want the focus to be on their bodies and the connection they share.

DIGITAL MANIPULATIONS

When creating photography for sale, it's irrelevant how we do the final images. I prefer a natural background, but if there are distracting elements drawing attention away from the subject, they should be removed or retouched. I like to shoot individual portraits with a wide-open aperture to blow the background out of focus, but this isn't always possible with group shots when faces must be sharp at varied distances.

In those cases when a tree, telephone pole, or other annoying element challenges your beautiful portrait, it is comforting to be able to quickly and efficiently retouch. I recommend that photographers sharpen their digital retouching skills (and charge

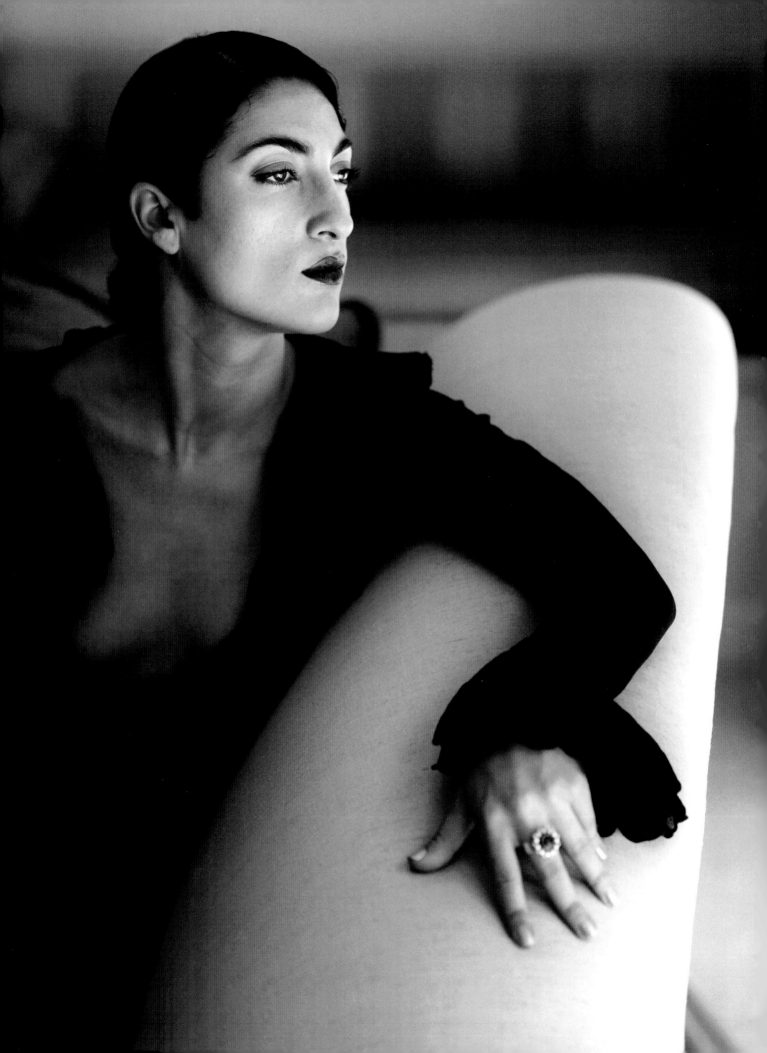

their clients an added fee, of course) because clients have come to expect this service. Retouching makes your images look better, and it can increase your profit margins.

BODY LANGUAGE

Folded arms can give a feeling of relaxed confidence, but the pose is not recommended for use with heavy people or men wearing tight-fitting suits. Folded arms can also make the subject look arrogant and aloof. Having a person pose with their hands on their hips can show confidence (think of the ads you see that say, "Look at me. I just lost fifty pounds!") Posing a subject with both hands in their pockets or behind their body can give the appearance of amputated limbs. Occasionally, men who may have been in the military or police unconsciously do the "cop pose," with their hands clasped in front of their genital area. This always looks defensive and guarded.

Encourage your clients to drop their hands and relax, or have a person lean against a tree or fence post or maybe place one hand in a pocket. I also like to give people a book, their glasses, or their favorite pet to hold. It looks more natural.

CAMERAS, LENSES, AND FLASH

I shoot with Nikon film and digital cameras, because their functions and features are intuitive, and even with image stabilization they seem lighter than Canon. My favorite lens is a Nikkor 105mm f/2.8 portrait lens. It's fast and lightweight. My second favorite lens is a Nikkor tilt/shift lens. It has manual focus but automatic exposure. It's a little tricky at first and it doesn't work well with digital because the metering system is challenged when the lens is shifted. I like the shallow depth of field it creates in many of my film-generated, vintage-looking images, though.

MELANIE LITCHFIELD AND
SARA BRENNAN-HARRELL

www.whiteboxweddings.com, www.whiteboxkids.com

Melanie and Sara both studied commercial photography at Randolph Community College in Asheboro, NC, and interned at various commercial studios. Melanie worked with mostly commercial and editorial photographers in Raleigh. Sara did an internship in Portland, OR, and then worked a while for a furniture photography studio. When they were out of school for about a year, they opened a studio together with a third photographer. Each had a separate businesses and shared studio space. Sara was photographing weddings and children, and Melanie was trying to shoot food "without much success," she admits. She took a job as a photo editor for two years at Pace Communications and shot with Sara on the side. Inevitably they left the shared studio and merged their businesses to become Whitebox Weddings/Whitebox Kids in Madison, NC. You can read their blog at www.white boxblog.com. (Note: Melanie provided answers to my questions, speaking for both partners.)

RESPONSIBILITIES

When we joined our efforts, we really changed our business model and began shooting in the personal ways we always preferred. Whitebox was created in 2006, and we shared responsibilities. Until mid-2009, we shot portraits and weddings together. This enabled us to develop a cohesive style that blended two different shooters' approaches. When we became too busy to collaborate on all the photography, we found it was a useful problem to have! Now we shoot most portraits separately and we will be shooting weddings separately in the 2010 season.

As far as postproduction work is concerned, we try to split it evenly. Sara does a lot of the editing to select the best images, and we both try to do the digital image editing and contribute to our blog. We don't have a rigid system; we just try to roll with what needs to be done at the time. I handle the marketing,

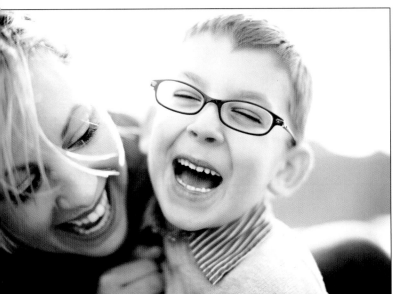

into offices and a meeting area. Occasionally we'll photograph newborns here, but we mainly shoot on location. Sara lives across the street from me, and together we own about fifteen acres of farmland and forest. Sara's area has a collection of old barns that we use as shooting locations. We call it "the farm," even though we just have dogs and cats. If we schedule sessions for our outdoor "studio" and it rains or snows, we just re-schedule. We also shoot at urban homes, but usually we work outside.

YOUR SPECIALTIES

We photograph a lot of children in the Greensboro area, but most of our weddings are in cities such as Raleigh, Charlotte, Wilmington, Asheville, and Charleston. Two to three events a year are destination weddings and are farther away. We have a studio manager who does most of our booking and administrative work, and she is able to work remotely from Atlanta. We are using assistants at weddings in 2009 since Sara had her second child in May. We will use

our web site, and the wedding albums. Sara handles the finances and all of the reprint orders.

YOUR STUDIO

Madison, NC, is just north of Greensboro. Our "studio" is in my daylight basement, which we converted

past interns as assistants for all of our 2010 weddings. Usually we work with two or three different interns per year.

GETTING ACQUAINTED WITH CLIENTS
We explain to our clients how we work when they e-mail us about our pricing. We try to be very up front about everything. Personality is a huge part of the business. There are a ton of good photographers out there, and most people don't know the difference between good and great images. If they are hiring a photographer based only on a review of their images, they will most likely choose the less expensive shooter. If they hire you because they have met you or have a recommendation, there is a lot more trust and a relationship is building. Hopefully, you'll be invested in each other and can work as a team to create great images. It's hard to achieve that if you don't connect.

None of our portrait clients meet us before a shoot. A few wedding clients meet us before they book. A lot of them come to us as a result of a word-of-mouth referral. Others trust us after seeing our work online, or interacting with us on the phone and/or by e-mail. We have a list of references they can call, but they are not requested very often. I think we owe a lot of the up-front trust to our blog. We put a lot of our personal lives into what we write, and people feel like they know

us. We also send out an informational sheet that outlines our portrait pricing.

PORTRAIT POSING
We decide where to take portrait clients after we talk to them and discover what they like to do. If they are more into nature, we might photograph them at the farm or in their backyard. For something more

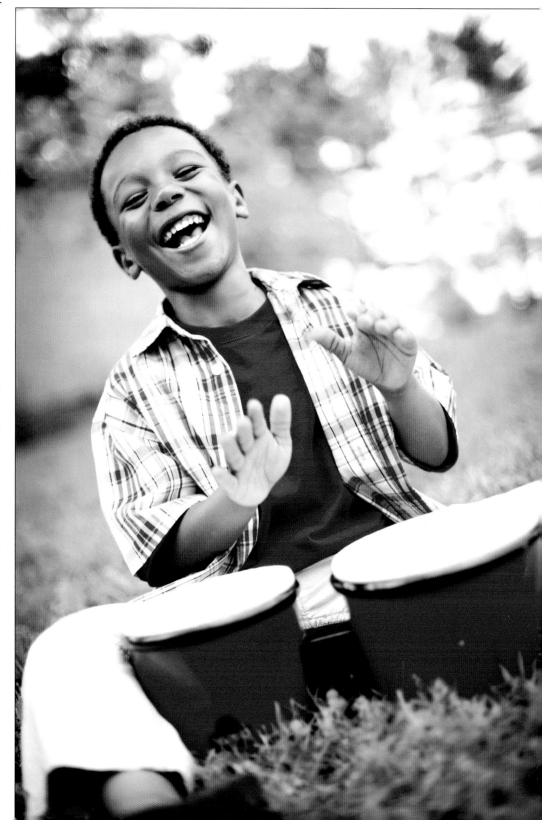

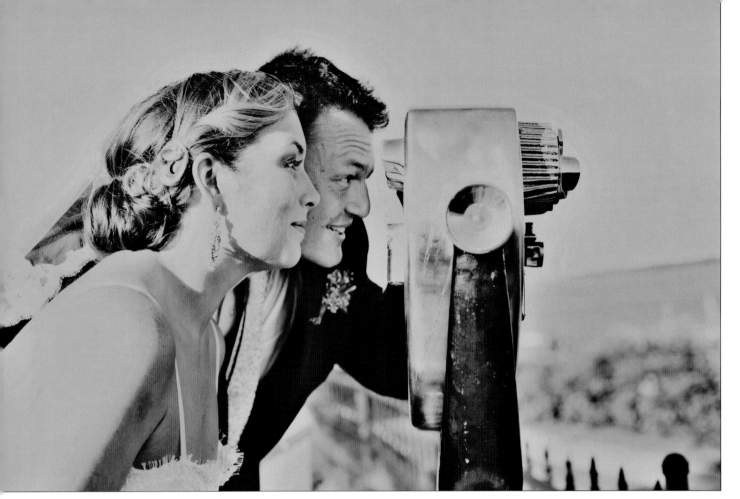

urban, we go downtown. We are familiar with many locations and we scout out others when time permits. If we don't have time, we'll roll with it and scout on the go. We're used to shooting in varied circumstances. With weddings, we got used to just showing up at a location that we had never seen before and making it work, so we do this for portrait sessions when necessary. We can usually make any location work, from a suburban backyard to a wall of graffiti in the city.

We call our portraits "posed candids." We usually give clients direction about what to do, and then try to get candid-looking shots as a result. I think our approach comes from having a commercial background. We usually have subjects doing something such as walking, laughing, jumping, making faces, kissing, etc. They aren't standing still very much, and because of the way we shoot, we take a lot of images. We aren't like a more traditional portrait photographer in that way. We're looking to capture a mood rather than a perfect pose.

CAPTURING MOODS

Some moods come naturally, but often they are coaxed out of subjects by having them interact with each other. I might ask them to be silly, or to laugh, or be serious or sweet. Often when we ask them to be serious, I get the best smile. With kids I might yell "tickle fight!" or ask siblings "Who has the stinkiest feet?" We do whatever it takes for people to feel more comfortable in front of the camera.

FAMILY PORTRAITS

We do a lot of family portraits at various locations, and often on our own property. Families have favorite places to pose. Every session is different. Even if we photograph two different families at the farm, the images don't look the same. We choose different spots or use different lighting.

Our most important job is getting the family to interact. It's nice to get that one shot where everyone is looking at the camera and smiling, but it doesn't always happen. We might put them in a more traditional pose and then tell them to laugh like crazy, or

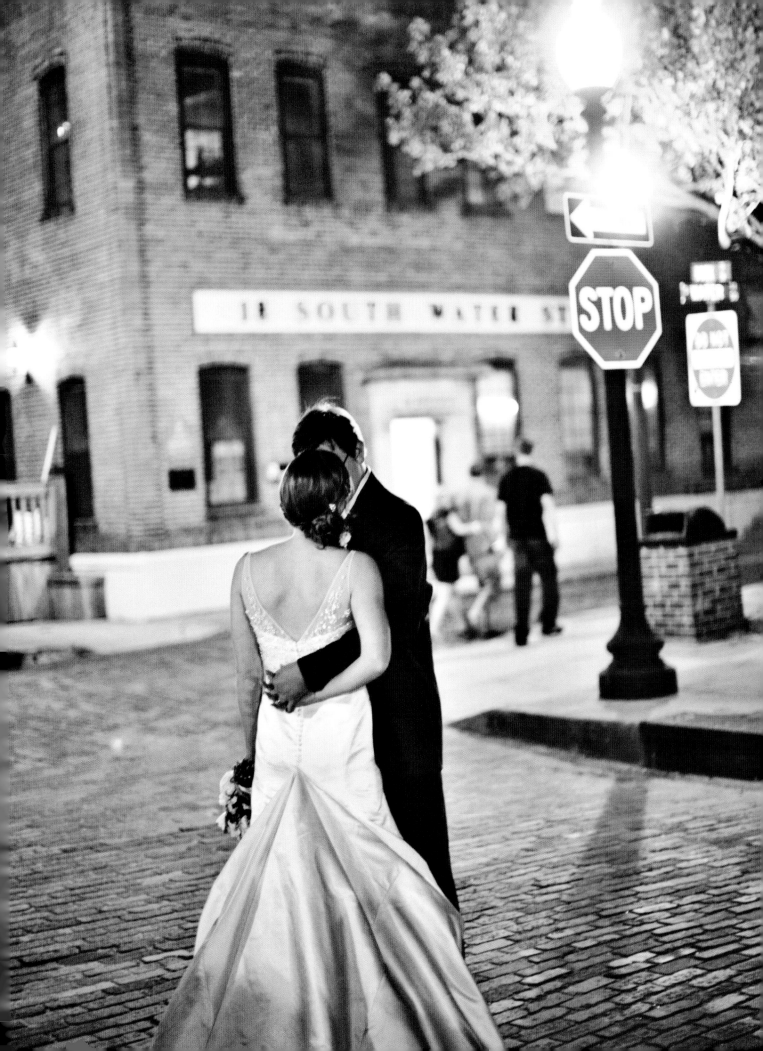

ask the kids to go wild. We like a little movement in our images.

We like the shoots to be fun so that everyone has pleasant memories. It often involves something silly, like jumping or piggyback rides. Or I'll ask one sibling to tell a secret to the other. If that doesn't create a reaction, usually the parents will help, like do a silly dance or tell a joke. It's no fun to look back at the pictures if you weren't having fun. A few times we have photographed families who were just the wrong clients for us, but we still ended up getting some good images, maybe not as many great ones as usual.

VARIETY IS KEY

Our posing is pretty flexible unless we're trying to place the sun in just the right spot, which is more exacting. We demonstrate what we want most of the time unless the subjects just naturally fall into good

poses. We try to get some good getting-ready shots, at least one photograph of the bride and groom that shows their eyes really well, some looking at each other, serious and laughing, a good first dance shot, a good "dance party" shot where guests join in, a shot of the bride interacting with her mom and/or dad and siblings. These are indigenous situations, and in addition we just try what we know works well with most people.

FIRST PORTRAIT POSES

Really, the only problems that arise when posing portraits are when people just won't relax. We try to talk to them the whole time so they aren't focused on the camera. We ask them about themselves—how they met, where they are from, etc. We can always find things in common to connect with. We don't have any "mandatory" poses, but we do try to get good

close-ups and full-length shots of both the bride and groom. We never pose them at the altar, cake cutting or dancing, because we approach these situations as they happen naturally. Sometimes it takes a while, but these situations happen and most people warm up.

ENCOURAGING IMPROVISATION

We do encourage clients to improvise, and some people are better at it than others. If it's not working, we'll just give them more direction. During the first part of a wedding day, about 50 percent of the pictures are spontaneous and the rest are done per our suggestions. At the reception, it's pretty much all photo-journalism. Most people are pretty co-operative, probably because they've looked at our web site and know what to expect. At a wedding everyone feels like posing in one situation or another, and we accentuate the positive. We've had a few problems with grooms [warming up to the camera], but none that we can't overcome with a few jokes.

INSPIRING GOOD EXPRESSIONS

When we are shooting portraits, we ask everyone to give us their biggest laugh, and we'll demonstrate it ourselves first. If they don't feel like laughing on their own, they'll just laugh at me, and it's contagious. Sometimes we'll stand on a chair to encourage a large group to let go. We may start with a seated pose, or

THE IMPORTANCE OF LIGHTING

For portraits and at weddings we shoot everything in daylight when possible. Almost all wedding formals are done outside of the church. We look for clean backgrounds with no distracting elements. At times, we'll just choose tress as the background. With the exception of a ballroom, we rely on ambient light almost all the time. Indoors, when light levels are low, we may boost the ISO level or we'll switch to off-camera flash.

We almost always do group shots outside in open shade or backlit. We never use fill flash outside during the day. For wedding receptions, we use on-camera flash and an assistant holds an off-camera flash in a small softbox that is fired with a Pocket Wizard. We also use a Photoflex softbox on a light stand at times.

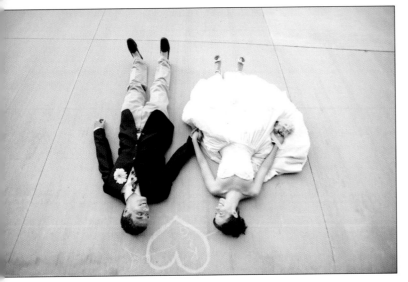

maybe standing, and we'll shift subjects to other positions to mix things up a bit unless they shift themselves as we go along.

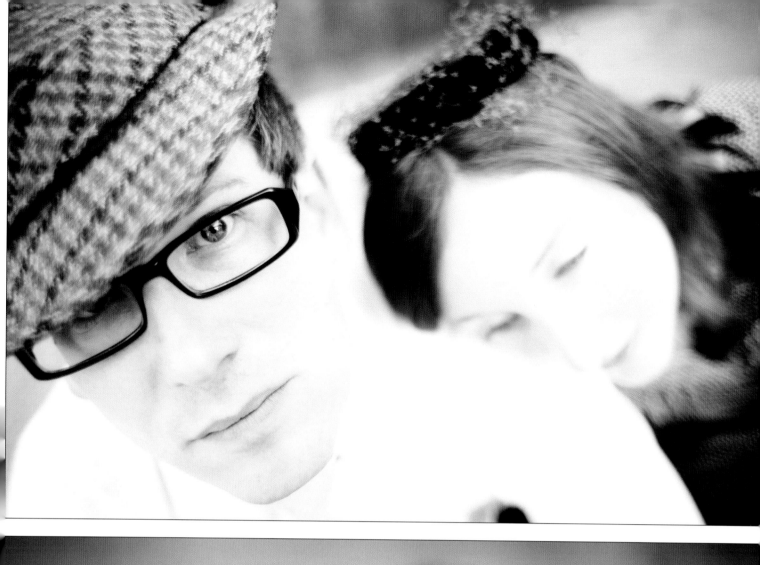
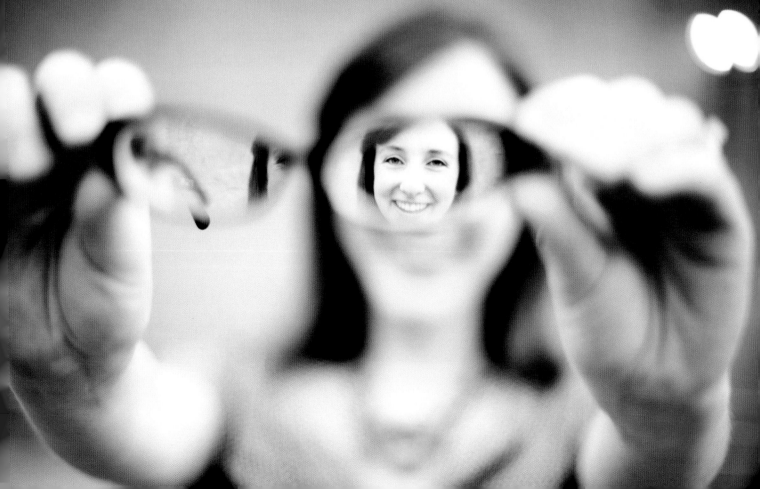

In the middle of a sunny day, we try to shoot in the shade. Later in the day we'll shoot with backlighting. We almost never shoot with front sunlight unless we're using a super-wide-angle lens. With portraits of a single person I rarely stop down to more than f/2.8. I like shooting at f/1.4 and f/2 to ensure softer backgrounds.

We approach lighting instinctively. We know how important lighting is to fine photography, but we're not very technically minded. We just make sure that the lighting on faces is even without harsh highlights or shadows.

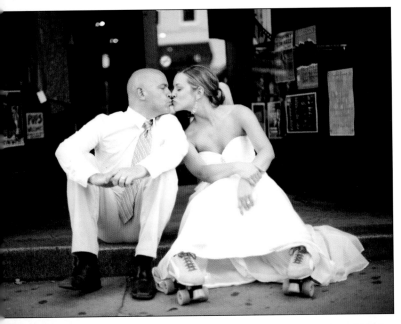

FLAWS AND EXCESS WEIGHT

Do we shoot differently if someone is overweight? Not really, though we might take a few more shots from above. We just want people to look happy. They look best if they are sincerely happy. Some clients may point out that they don't like a particular side of their face, and we'll try to angle and light that side carefully. We just don't do profile views of large noses. We're aware of physical conditions, but if someone really hates the way they look, they probably won't like the pictures no matter what you do.

USING PROPS

We sometimes use props, but more for kids than adults. It's best to just use props that go with a subject's personality. For instance, if someone plays the guitar we might use that, or if they like to ride bikes we might include one. We don't do indoor portraits often, but we might have a kid jumping on their bed. Sometimes we bring indoor furniture outside to make people comfortable. We use bubbles a lot, hula hoops, paper airplanes, ice cream, cupcakes, whatever is fun. Fences or barn doors are good props. I'd say we use whatever we can find in the environment to give photos a sense of place.

SHOWING PICTURES WHILE SHOOTING

We never show images on the back of the camera unless it's to a kid. Toward the end of a wedding reception we do present a short slide show of the wedding day images.

DIGITAL ALTERATIONS

We don't really tweak faces or figures very much. On occasion, we might have to switch heads if we don't have a shot where everyone looks good in a group, or if someone kept blinking, but these occurrences are rare. We don't Photoshop someone who wasn't there into a group.

POSING OLDER FOLKS

Sometimes it's harder to pose adults who may be more self-conscious than average and may have to be

coaxed out of their shell. At weddings particularly, some groups are hard to assemble. They're not reluctant, just unruly. We have to talk really loud without screaming and sounding bossy. When a few people quiet down, the rest usually follow.

POSTPRODUCTION

We handle all of our own postproduction work. We farm out album prints and wall prints to a lab and do the album design in house.

CAMERAS AND LENSES

We both use the Canon 5D. Our favorite lens is the 50mm f/1.2. We also use the 16–35mm f/2.8, the 28mm f/2.0, the 85mm f/1.8, and the 135mm f/2.8 occasionally. We frequently shoot wide open, but for a large group we may stop down to f/4 or f/5.6 with a wide angle or 50mm lens, depending

on how many people are involved and how they are arranged. For smaller groups we use the 50mm or 85mm lens.

RON JACOBSON

Ron joined a camera club in junior high and later studied photography on his own. In the 1970s, he enrolled in a photography-by-mail course. He was going to apply to a trade/technical school for photography, but after visiting with some officials, found he was already beyond their teaching. While working many years at his parents' grocery store, he sought a photo apprenticeship but eventually took a job as a photojournalist for a weekly newspaper and expanded his education by joining local and state photographic associations. Today, Ron runs two busy studios in North Dakota.

MORE BACKGROUND

In the camera club I joined in junior high, we taught each other camera techniques plus black & white darkroom work, which got me interested in Ansel Adams and other black & white photography masters. Later in my career I spent about a month each year at local, state, regional, and national seminars and conventions to continue learning. Eventually, my wife and I taught classes on photographing high school seniors, children, and weddings, as well as framing, matting, and techniques in Photoshop and Painter.

DESCRIBE YOUR STUDIO

We have two studios. One is in Mayville, which has an area population of about 3500 and is in the heart of the Red River Valley surrounded by farmland. The other studio is in urban Grand Forks with a population around 65,000. The studios are 35 miles apart, and together they extend our sessions to a 100-mile area with potentially 250,000 people. It's not a very upscale population, but there are pockets of wealthy people. We started our business on September 1, 1978, so we've been in business for more than 30 years.

We have full-time and part-time staff that work at each studio. We started our Grand Forks studio 23 years after opening our Mayville location. The Mayville studio is still busier than the one in Grand Forks, but due to population shifts, that could change in the future.

We photograph in both studios as well as on location in parks, urban alleyways, and our own home yard, which is landscaped for photography. Some parks work well for larger family groups, but our spacious yard offers many areas for individuals and families too. We experiment in other locations given the

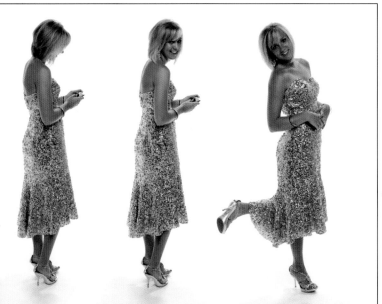

right lighting, and I do most location shoots with off-camera softboxes, usually on a stand, but sometimes held by an assistant when that's necessary. In this way, I use the ambient light for fill and control the main light with my own source.

Since our Mayville studio is still doing more business than Grand Forks, I work in Mayville more often. We run a number of larger promotions in Grand Forks that bring us a couple hundred sessions over a two- to three-day period. Usually these are worked in conjunction with fund-raisers for non-profits.

DIVIDING THE WORK

My wife, Toni, has worked alongside me for all these years, doing everything from assisting during sessions, to printing photos, selling, finishing orders, doing bookwork, and maintaining our databases. Now she is mostly studio manager for both locations, setting appointments, selling, and delivering the photos. She also works on marketing with our graphic designer. I do most of the photography, though we still photograph weddings together as well as many portrait sessions.

I do a lot of the computer and design work, sharing retouching responsibilities with our full-time graphic designer. Our framer is also an employee, and we have part-time employees who work on orders, clean up, and answer the phones.

YOUR SPECIALTIES

I'm not a specialist, because being in a small market pushes me to take all kinds of jobs. We do families, children, seniors, and weddings in that order from most to least. We also do some commercial work and some school and sporting events. All of our product lines are priced for about the same amount of profit, though I would say our high school seniors make us more profit than our other client demographics.

GETTING ACQUAINTED WITH CLIENTS

To get the response and support you want from your clients, you must develop a personal relationship with them. You need to be proactive, but also feel out clients to avoid pushing them out of their comfort zone. My conversations during sessions get very involved. With high school seniors, I find out what type of work they've done, what classes they take in school, their plans for after graduation, and any hobbies they might have.

I discuss personal topics, but only when a client brings up the matter.

An outgoing personality is a big asset to a photographer who takes portraits. With a bland personality you may have problems relating to your subjects. One of my gifts is the ability to be a chameleon. I've noticed that other successful photographers share the trait. We adapt to each type of client to make them feel more comfortable, which allows us to capture

their natural poses. Too many photographers just seem to put all their clients in the same poses, which doesn't take advantage of their potential.

FIRST PORTRAIT POSES

Comfortable poses are the best place to start. Clients have different body types and body language. When you find poses that are comfortable for them, work from there to modify those poses into others they will feel good about. I sometimes show my clients the pose, but I am equally comfortable in adjusting them from a distance using human remote control—in other words, I use my fingers and hand gestures to suggest movements.

Many people become stiff when posing and don't allow their natural personality to shine through. A pose needs to look pleasant and be pleasing to your client. Even somewhat contrived poses need to feel comfortable or your clients will show they're not relaxed. When you have experienced success with posing, you will know by instinct how to direct a variety of worthy poses.

High school senior poses are usually all over the board. Try every type of pose that offers variety to stimulate their orders. Wedding and engagement portrait clients and families usually want familiar poses, groupings, head shots, etc. Intimate poses are usually close ups and are more physically involved, and some are likely to be full length. Natural sitting, standing, and reclining poses give the subjects a sense of well being, making for better portraits. Popular poses come and go, but you will find that some stick around forever.

ENCOURAGING IMPROVISATION

Depending on the comfort level of the subject, improvising can be encouraged. It works best with children and outgoing teens. Their poses may be good, or they may be just what they do at home looking at themselves in the mirror. Improvisations can create excellent poses because they feel good to clients in various photographic categories.

INSPIRING GOOD EXPRESSIONS

I encourage good expressions by being personable. I know what type of joke or comment will make a client smile or be serious. Since a lot of clients have been with us for many years, it's easy to ask about girlfriends or boyfriends or sports events you've seen them at. My approach depends on the expression I'm going for.

Group dynamics and getting everyone's attention is probably the toughest. Typically, most of the group cooperates, but there's always one or two who seem unaware. We don't do many poses of large groups, but we can change out a person's face with another shot in Photoshop if necessary.

THE IMPORTANCE OF LIGHTING

Lighting and posing go together like hand and glove. Fit good lighting with good poses and you will get great portraits. I usually start with the pose and then adjust the lighting. If you set up a lighting pattern first and try to cajole the subject's face and figure to suit it, you may not get a flattering portrait.

Lighting patterns such as Rembrandt, split, and butterfly have their place and can hide or accent certain areas of the face. Shadows create the illusion of depth, or three dimensions, in a portrait, and they can also take off weight and add a sense of mystery in a pose.

Moody lighting can be used to intensify an emotional portrait. Normally a standard, looking-at-the-camera pose doesn't need moody lighting. But certain clothing, emotions, and types of portrait subjects—perhaps creative or romantic individuals—will benefit from moody lighting. You can use a spotlight, a high contrast ratio, or even subdued lighting with fog or scrims added to control the light and shadows on a face or background.

USING PROPS

Props are a big part of many sessions. Their use is usually dictated by the comfort level the subject has in posing with them. If a prop helps a subject to be more at ease during the session and adds to the portrait, use it. For certain poses, props are necessary—especially with teens, who often feel more comfortable with them.

DISCUSSING WHAT YOU ARE DOING

Depending on the client, I sometimes talk about changing the lighting or props. With children, I may do it simply to distract them, but a large family doesn't need distractions because I need the group's attention. For individual portraits, I might give the subject some idea as to why I'm switching the lights or lowering the camera. Generally, I'm finding out about their likes and tastes. Once I strike a chord, they are very interested, and I can usually keep them talking about things that will put them at ease while I work.

FACIAL FLAWS AND EXCESS WEIGHT

Overweight people and those with other physical flaws bring their own set of problems for photographers. Posing an overweight person straight to the camera is usually a mistake. Pose such a client on the edge of a chair, leaning forward with one hand/arm forward to downplay their size. The proper lighting from the front at a slight left or right angle may be even more flattering.

Facial flaws such as wrinkles, big noses, and weak chins are handled through skillful posing and lighting combinations learned through practice. Mistakes usually become good teachers.

TEEN POSES

Senior poses are more contemporary, often fashion magazine oriented in nature. Some seniors are very easy to pose just by suggestion. Others need lots of direction and refining. They usually bring multiple clothing changes and familiar props such as guitars or favorite stuffed animals. Teen posing tends to be casual—for example, lying on the floor or on furni-

ture, or maybe leaning against objects such as walls, cars, or gates. Many of my best teen poses originate with the teen as they're relaxing and waiting between poses, background changes, etc.

POSING YOUNG CHILDREN

I can usually get children to follow some of my directions by age three or four. It's amazing how you can demonstrate a pose to some kids and they'll repeat it for you. Their natural movements are great but cannot always be captured in a way that suits parents, especially if the mom wants a face-to-the-camera look. We find that spontaneous poses may be best suited for collages that include a number of images.

We can find out what kids like and work from there. For instance, some kids love it when you refer to bodily functions—they love the words—and they may interject posing along with amusing comments. Those portraits can be among the best from a session.

POSING GROUPS

Many new photographers will gather a group of people into rows and hope the shots work. In our studios, we spend time looking at the relationships of families, grownups, teens, and kids. From our observations we build mini-triangles with people on the floor, on stools of different heights, standing, and even sitting on laps. Our goal is to see everyone and maintain and show relationships. We have blocks for some of the subjects in the back row to stand on so they can be seen clearly.

If we aim to create a large wall-art print, we work on the interaction between family members and leave space to

create the environment around them. We use a ladder or a higher camera angle if it improves our group portraits.

Lighting groups is a little different from lighting individuals. In some cases, you may place your main light off camera and feather it across the group to the far end, making sure that it is broad and high enough to cover everyone. It's also important that your fill light has all of your subjects covered evenly and is bright enough to fill shadows from the main light adequately.

CLOTHING FOR PORTRAITS

Clothing is important to posing, and we suggest that our clients bring certain types such as solid colors, long-sleeved shirts, and pants or long skirts. All these garments tend to move your eye to the subject's face. If you are trying for different portrait types where other styles of clothing fit, make specific suggestions. Some clients may expect a formal and a casual portrait in the same session. When this is the case, we suggest they bring different clothing that is appropriate for each portrait type.

DIGITAL ALTERATIONS

I'm a big fan of getting the image right the first time, but there are times when you'll need to add some-

one who couldn't make it to the session, or the image background might need some work. These alterations need to be done by a professional technician so that the changes are not painfully obvious.

BODY LANGUAGE

Body language is the basis for my posing. To me, standard or stereotyped poses are cheesy. Once a subject comes out of the dressing room, I usually engage them in conversation and study how they position their body—how they fold their arms or put their hands in their pockets. Discovering these characteristics is a fun part of most sessions. For a little girl, it might be posing like a model. For a high school senior, it might be portraying a certain attitude.

In business portraits, character is very important. You don't want a male subject to be posed in a feminine position (e.g., with his head turned in the opposite direction of his body and over his shoulder).

For a female subject, almost any pose will work. But if you are looking for a sweet, alluring portrait, using a dominant pose (looking in the direction in which the shoulders are turned with her head slightly tilted) will make the pose look too masculine. Knowledge of various poses and when to use them is very important for business portraits. When in doubt, experiment.

CAMERAS, LENSES, AND FLASH

Presently I use the Canon 5D or the 5D Mark II for portraits. Both camera bodies include a full-size sensor, and the files are large and very clean for portraits. My lens choice varies depending on the session, but my favorite is the 70–200mm f/2.8 IS. For families, I often use my 24–105mm lens.

I use Calumet Travelite electronic flashes in the studio, and on location I either use the Canon Speedlite 580 or Quantum Turbo flash, the latter usually with a softbox for very flattering light.

We have made a few backgrounds ourselves over the years, but most backgrounds are professionally made. Companies like Knowledge Backgrounds, Denny Manufacturing Co., and Amvona have very nice backgrounds for portraits.

TODD JOYCE

www.joycephotography.com

Todd Joyce attended Wilmington College in Ohio, where he studied sculpture, graphics, and design. The college only offered a degree in art and communications, but he took every photo course offered plus three independent study photo courses. He secured an internship in the college admissions office where he designed mailings and brochures and fulfilled other responsibilities. Many layouts needed photographs, so he began shooting mostly black & white. Coached by his photography professor, Todd completed his office work. Todd is now an advertising photography specialist with a studio in Lebanon, OH. From April 2008 to May 2009 he served as national president of ASMP (American Society of Media Photographers; www.asmp.org) and is now a vice president.

MORE BACKGROUND

After college, I moved to a small apartment in Cincinnati, OH, where the closet became my darkroom and I washed film and prints in the bathtub and sink. It was cozy. My first photo assisting job was with Photodesign, and it was an awesome feeling to work in a real advertising photo studio. Their work was beautiful, and I read the Sunday paper to see the ad pictures I had helped to create for shampoo bottles and other products.

After my temporary job, I did freelance assisting, often with Tom Rogowski, a corporate photographer in Cincinnati. I made the mistake of telling him that I had a strong back, and it got me the job. I worked with Tom for about four years and learned a lot. His style was dramatic, and he taught me about lighting and about the business. I remember that in Tom's work the people were posed, but they had a natural feeling from things as simple as a tilt of the head or a shift of their weight. I have been influenced by a number of photographers, but it was Tom's work

that gave me the kick I needed to create images in a dramatic way.

DESCRIBE YOUR STUDIO

I'm in my third studio since 1990. My first two were in Cincinnati where suppliers and clients were close by. But in 2004 I wanted a more rural area where I could live and work, and I found a house with four acres of land in Lebanon, OH. I built a 1500-square-foot dedicated studio off of my house, and I use adjacent areas for work as well. My barn comes in handy for large sets and dirty situations. I get called for all kinds of work on location, and if I need more space or a different environment, I find it. I used to have employees, but now I prefer to hire freelance help depending on my needs.

YOUR SPECIALTIES

I photograph conceptual advertising assignments primarily using people. Knowing your markets and what you do best is very important in advertising. I tell students, "Shoot what you love and you'll enjoy what you do."

I work on location in several states, as well as in my studio acreage. I never know what assignments will come in or where I'll be next, but that keeps life exciting. I've spent time searching for the perfect front porch, the right pool, or the perfect mountain range. Locations are not always glamorous, and there are times when I have to be knee-deep in mud or drywall dust to get the necessary shots. I prefer finding the right locations to building sets that do offer complete control, because I enjoy the challenge and serendipity of locations. I thrive on the energy of the moment.

I've worked with many models. Some were great and some couldn't figure out what to do in front of a camera. I actually enjoy working with real people, and I work at making them feel comfortable. Depending on the requirements of the shoot, a person off the street can serve as a model. I can usually have them tilt their head a bit to look more comfortable. If I am shooting a character, I prefer someone who

has acting experience. A person off the street just won't take expressions far enough for me.

GETTING ACQUAINTED WITH CLIENTS

In the advertising world, an incredible number of people are involved in the act of producing images. I may know the art director on a project, but it may be the first time I'm meeting the client who hired the ad agency, and that client may be involved in the shoot. I am always positive, no matter what I have heard. We're all there to get the best photographs we can, and everyone has needs to be met. We also have strict layouts in ad formats, and there is type that need to be constantly scrutinized and related to images. My job is to put the client at ease so that we are all on the same page.

When I repeat our photographic needs to the client in my own words to prevent misunderstandings, it's amazing how often I find that the client didn't mean exactly what they originally said. It also helps to keep lines of communication clear with account reps, art directors, stylists etc., because with numerous people involved, good communication is very important. When possible I also converse with models and other subjects in the ad photographs I'm doing. I enjoy being social, so I'm sure my personality is a big reason why I photograph people. The photographs are always better when the models feel I'm like a friend who is taking their picture. A photo shoot is like cooking. All the items need to be prepared technically well and seasoned properly, and when all of the ingredients come together, the photo is perfect. The art is arranging it all so it does.

PREPARING POSES

Photographing people for advertising can be tough when subjects are just not comfortable in front of the camera. Even a well-paid model may not be able to accomplish a natural look in an odd situation, so you need to know what you want them to do and be able to explain or show them what kind of poses you need. Some posing situations have flexibility, but others have no room for a pose or expression that does-

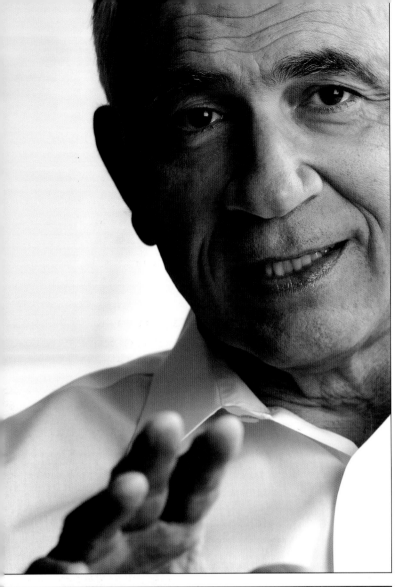

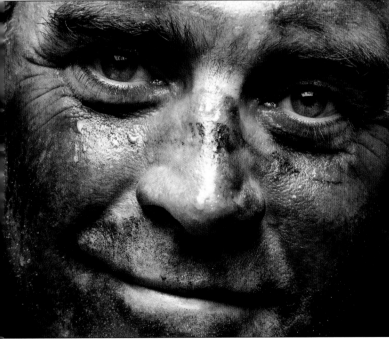

n't fit the ad message. I may need a person to pose in a specific and ideal spot with no space around them because a certain crop is required to accomodate the type treatments that will be used. In those cases, posing is crucial.

Looking natural in front of the camera is the hardest part of posing for some models, so I shoot at moments when they are between poses. I also talk with them and take pictures when they least expect it. I try to leave the camera on a tripod so the model talks with me and not at the camera. With the camera "out of the picture," there is no fear or apprehension. Sometimes I am able to choose whether to shoot head-and-shoulders poses, three-quarter images, or full-length shots.

I like an environmental look for portraits. It is harder to include the surrounding area and use some available light, but it tells more about people. If I'm just doing a headshot, I have my subjects lean forward to engage them more and throw everything but their faces out of focus.

If I have the space and freedom in an ad, I love to turn the subject loose. When they feel as though they are not posing, the shots are better. On the other hand, some people don't know what to do with the freedom; in such cases, you've got to be ready to direct them.

I have fun when I can inspire expressions I need. A joke can be helpful, but asking subjects or models about themselves is an engaging way to gain their trust.

THE IMPORTANCE OF LIGHTING

Lighting is everything in photography. A subtle tilt of the head and a turn of the face, if lighted well, can make or break the message implied in an image. A balding head, a large nose, heavy jowls, or a scar can be played down (or overemphasized when need be) through the right pose and lighting. Side light makes a face look thinner, and overhead light can make a subject look wider. Shadows can be dark and sinister, but too much fill light can make a person appear heavier.

It's sometimes difficult to study people in a setting and know when they look their best, so well-modulated lighting is critical to achieving a concept. Mood created by lighting plays a large part in what I do. My advantage is that I get to choose the model to portray the feelings, and I light the setting to be joyful or somber, or in between. Lighting can be a subjective matter, too.

USING PROPS

For some subjects, it's comfortable to have something to hold onto or lean on. Some people don't know how to handle having something else in the shot and look unnatural relating to it. In many cases, models and other subjects need to relate to props that are products or are involved with services, and experienced models do it well.

DISCUSSING WHAT YOU ARE DOING

I talk during sessions about what I am doing with the camera, lights, or poses. It is absolutely essential to keep people informed, and it puts them at ease to help them understand it's not their fault if you fuss over details. People like to see and hear what is affecting them, and I make them part of the process.

FACIAL FLAWS AND EXCESS WEIGHT

Asking someone to lean forward is a great way to minimize a double chin. Side lighting reduces a person's width, and a straight-on pose reduces the ap-

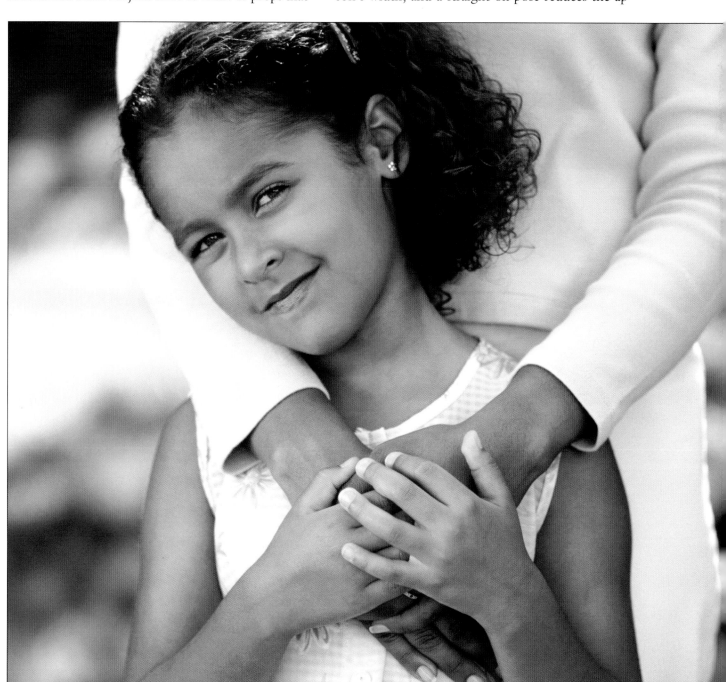

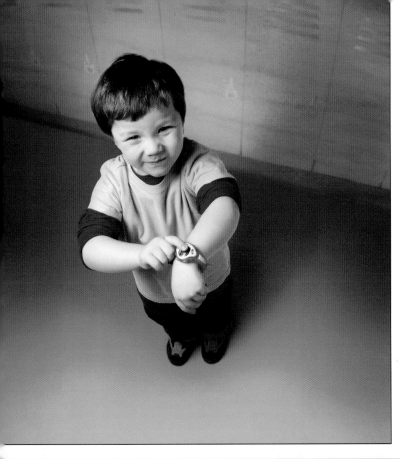

parent size of a larger nose. I have also photographed people to emphasize a nose, a heavier build, or other features to fulfill the ad concept via lighting. At times I work this out with the art director to coincide with the overall needs of the ad.

TEEN AND CHILD POSES

When creating photographs for ads using kids or teens, the concept is usually higher energy, so I often use different poses than those I rely on with adults. I portray energy through the actions of play and body positions. There are times when adult energy is also important for an ad, so I have to pose them in various active positions, and occasionally I use the computer to combine a pose that was impossible or not likely otherwise.

I work with professional kid models, plus some who just photograph well, and they are all fun subjects. I try to put them into a play or comfortable en-

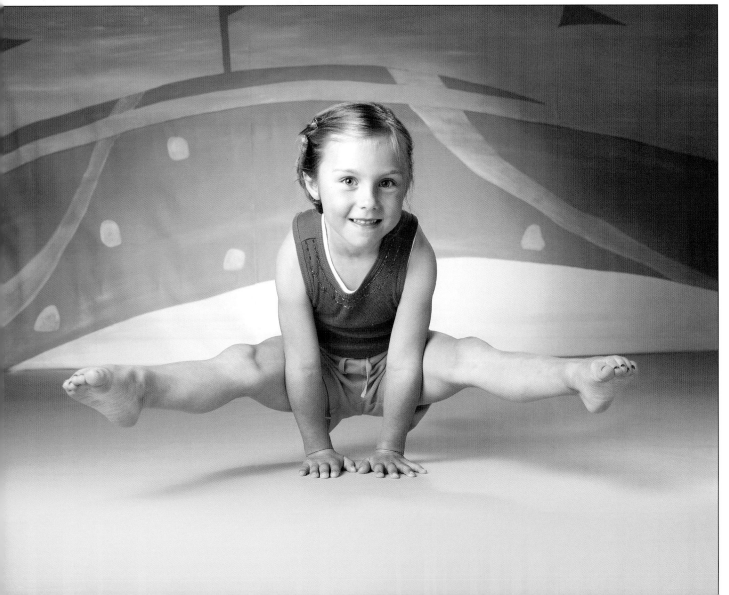

vironment. If you make posing a kind of game, they will do a lot for you. Kids and CEOs can also be about the same amount of trouble. I've had three-year-olds give me exactly what I needed, and I've had adults give me a hard time and not cooperate. A flow of conversation can help subjects of all ages to relax.

POSING GROUPS

I like directional lighting, so the way that people are positioned can vary depending on the number of subjects in the group. It's logical to position people in a pattern that suits their size and number.

Ladders are a great way to solve a lot of problems. I've shot straight down on groups.

I work hard to remember everyone's name, even when working with large groups. I had more than twenty people in a corporate group, and I was able to say, "Ted, turn your head to the right," then ask Melinda to move down a step. The group was in awe and rewarded me with their complete attention. Remembering names is especially helpful when photographing a corporate board, when you can say to important people, "Mr. Wallace and Ms. Brooks, please turn slightly to your left. Thank you."

CLOTHING FOR PORTRAITS

I like solid colors. Stripes and patterns often seem distracting. I often have a say in what the models wear. Color and tone can complement or distract from the lighting and the emphasis for the shot, so I may work in tandem with the art director and stylist on choices. I always ask the talent to bring lots of clothing choices, even if we have purchased clothes for them. A model may bring the perfect outfit. Sometimes I may need a good stylist to buy clothing before the shoot. Clothes can influence a pose, be-

cause styles can add freedom or take it away. Try keeping a suit and tie straight if the subject is moving. Or try to let someone go wild in a tight outfit. It will quickly become evident that clothes can make or break the situation.

DIGITAL ALTERATIONS

Digital enhancements can help us to make things happen for our clients. Dropping out a background

or adding a person who couldn't attend the shoot are among the possibilities. The more you can offer your client, the more likely they will use you again. I do most of my own digital work and take care of all color adjustments and retouching. There are times when I combine many shots to make one. I'll use the arm from this one and the head from another. I feel like Dr. Frankenstein sometimes. The trick is to keep the image from looking like the monster.

BODY LANGUAGE

Crossed arms used to say that a person is closed off, but that's not true if you can show the right body language within the pose. Shifting weight onto one leg with a little head tilt and slight turn can make a CEO with his arms crossed look friendly and inviting. A slight leaning forward can make someone look more inviting and less detached. I observe the body language of the people I photograph and put it to work or alter it to suit the purpose of the ad.

In advertising, when I am asked to photograph people showing emotions such as anger or confusion, body language and lighting play an important part of

conveying mood. Some images need to look natural and some look stylized, so working with subjects to achieve the look requires a combination of good people and communication skills. Knowing what you want in style and mood comes first. Previsualizing and having the technical skills to make it happen through precise posing to fit your concepts in a production shoot can be a challenging combined effort.

CAMERAS, LENSES, AND FLASH

I use a PhaseOne digital back attached to a Mamiya RZ 6X7 camera and a Nikon D300. The Mamiya bellows and leaf shutter offer limited focus options at times because I like to shoot wide open, so I can tell the viewer where to look. Yet my images are beautifully sharp because the PhaseOne digital backs offer extremely good resolution, great skin tone, and beautiful coloration. However, I'm doing more DSLR work recently, now that the megapixels are high enough for larger outputs.

I've used a Balcar strobe system on location and in the studio for years. I have fifteen strobe heads,

but I rarely take that many out with me unless I know I'll need them all. Too many lights look artificial. It's amazing how one simple light with some available light can look. Simple can be beautiful.

LARRY PETERS

www.petersphotography.com

I think of Larry Peters as an Ohio photo studio tycoon. He and his wife Karen (whom he met in kindergarten) own and run portrait studios in three Ohio towns—London, Dublin, and Centerville. He says experience has shown that portraits made in a studio have an aura of professionalism that he feels is superior to many images shot on location. Adjacent to the studio in his London home Larry enjoys a swimming pool where he or son-in-law Brian does delightful senior photography. Karen is in charge of studio operations and works with their daughter Janine as an efficient team.

ABOUT YOUR BACKGROUND

I was a high-school newspaper advisor when I learned photography to teach my students how to take pictures for the paper. My older brother was shooting weddings, and he taught me the basics. I attended the Winona School of Professional Photography in 1974, studied portrait lighting, and went back in 1976 for the advanced course. After a part-time stint I became a full-time studio photographer in 1981. I learned marketing from Gary Jentoft, sales from Charles Lewis, and my photography skills were modeled after Bill Stockwell, Wau Lui, and Rocky Gunn.

ABOUT YOUR STUDIO

Our studio has grown from a location in London, a rural Ohio community with a population of 10,000. For more efficiency we branched out to a location in Centerville (near Dayton), and we opened another studio in Dublin (near Columbus). We now have 26 full-time employees and a few part-timers, giving us

YOUR SPECIALTIES

Working at our studios are four master photographers. My daughter Janine Killian and her husband Brian Killian are absolutely wonderful with children and families. I like children, but I don't like photographing them, so Janine takes the lead, and she has the support of five other photographers when she finds that she needs it.

I hate shooting on location, because today most part-timers are doing all of their sessions on location. The problem is locations are available to anyone, and though my portraits may be better lit and posed, people might say the part-timers' work is good enough. So I enjoy being very successful as a studio photographer, and I feel that our clients appreciate the distinction. With skill, studio photography allows you more photographic opportunities and you can charge more. Your work creates an aura of professionalism which can look different than others, thus drawing attention to your studio.

GETTING ACQUAINTED WITH CLIENTS

When your profession is photography, your concurrent occupation is marketing. One supports the other. We do everything possible to attract clients, primarily with sales on session charges. We offer additional discounts if the clients will come to the studio for a consultation. This gives us the opportunity to make suggestions about session choices and client interests such as clothing. You must get into their heads and give them what they expect, even if it's not what you think it should be. Today's clients seem to be going for more relaxed posing and interactive posing. If you are not a people person, then you shouldn't be a photographer because posing is all about intuition and interaction.

the opportunity to be photographers, retouchers, printers, digital production and salespeople, and we have our own lab. We do our own mail campaigns, and everyone is able to substitute in other areas, which includes landscaping, painting, and maintenance chores.

It takes a great deal of effort to keep a business growing over the years, and I know the reasons why we're still here: great marketing, fresh photography ideas, and developing products that our clients want. These have been basic to my business plan for over 30 years.

PREPARING POSES

The correct approach to posing is to work with people until they look good. I know that seems a little flippant, but it's the truth. People want to look relaxed and real in their portraits. That said, it is your responsibility to look at them and find problems they may have. As a professional, you must make heavy subjects look thinner, the thin look great, the young look older (sometimes), and the older look younger. It takes observation and testing to make this magic happen. If your camera is tethered to a computer and you check the images throughout a session, you will be able to observe and solve these problems. With an untethered camera, check the LCD often enough to make pose corrections when necessary. View images in the camera room with your client and ensure their satisfaction. By reshooting if necessary, you can avoid clients being upset.

FIRST PORTRAIT POSES

The type of pose I start the session with depends on the purpose of the portrait. For a business portrait, I may start with a head and shoulders pose. For a high-school senior, I may begin with a full-length shot. A portrait session needs to be somewhat pose specific but thorough. If you eliminate important pose choices, you may limit your sales. For instance, it is shortsighted to assume that a heavy client won't buy an image in which they appear in a full-length pose. Your assumption could ruin a wall portrait sale. The best approach is to create flattering poses in all possible situations to help maximize your sales. I feel that about 25 percent of portrait poses should be full length.

ENCOURAGING IMPROVISATION

Your spontaneous responses in portrait sessions show that you're thinking and caring about subjects and their ideas. This will get you a long way, and it encourages people to improvise and stay loose. When shooting a group, try to keep them all happy. If you antagonize someone because you don't agree with their ideas, you may cause yourself pain throughout the whole experience. The client may not like their portraits, even if they are great. Stay positive and enjoy exchanges with clients.

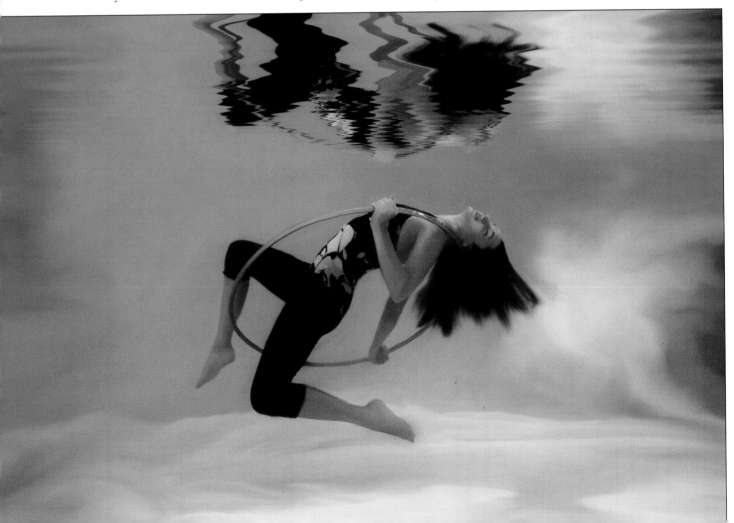

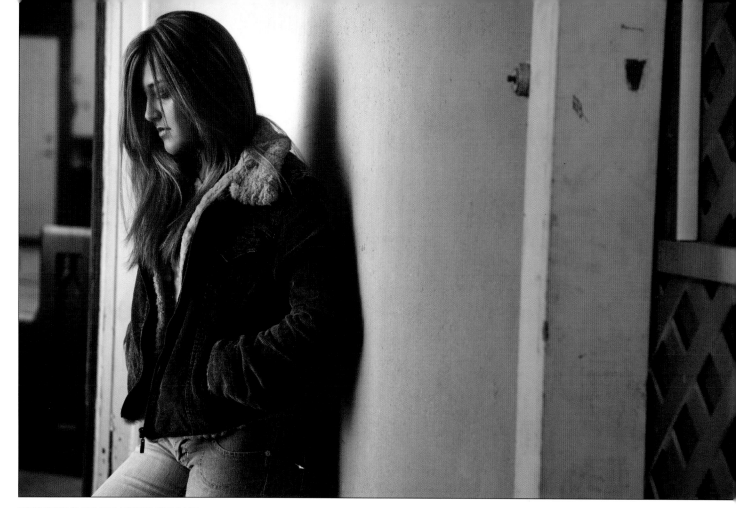

INSPIRING GOOD EXPRESSIONS

I work primarily with high school students, and I learned a long time ago that getting along is all about honesty. Smile honestly at your client and they will smile back. Your clients' expressions will mirror what you give them. The best practice is to keep noise and distractions at a minimum. Talk softly and get them to like you as a person, not an entertainer. This takes patience, but the rewards are great. You will have an easier time working with teens and their expressions will be real. With children, it is better to make the room very quiet and whisper to them. Don't jump around, you may scare them.

THE IMPORTANCE OF LIGHTING

Lighting for a senior is all about drama that achieves varying appearances. I like to use a large softbox close to the subject for a soft appearance, and I use kicker lights and lighting you see in commercial advertising. For some images, I concentrate lights on the face and allow the rest of the body to be a little darker to ac-

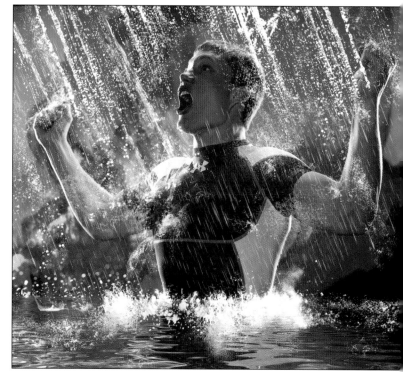

centuate special features. We like to use colorful backlights in many cases.

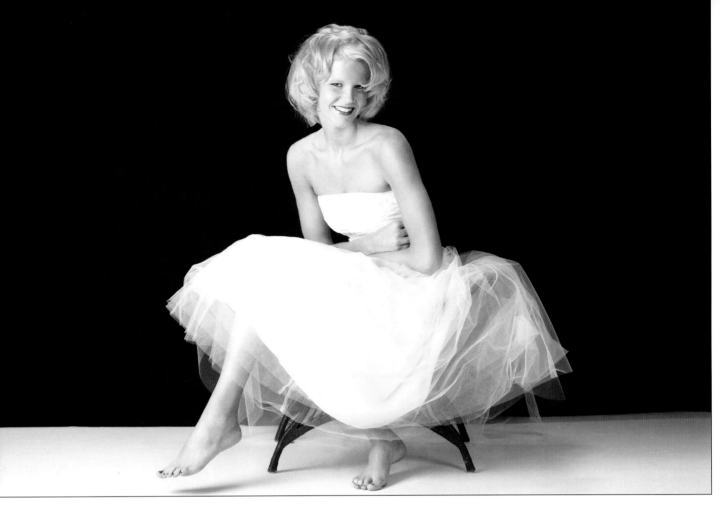

If you look at a portfolio of images and see white, brown, or gray, you have a problem, and it may be lack of variety in lighting and backgrounds. Colorful backdrops and creative lighting produce a more dramatic effect that is fast becoming popular in our family and children's sessions. Everyone is tired of dull and boring settings. They want to appear in the commercials they are seeing. Study magazines and advertisements and re-create the looks you see, and you will be right on.

USING PROPS

Props help define me as a photographer. Some photographers may purchase a new prop and use it until they are sick of it. We have built up a stock of props that fit when needed. We have a catalog called JL Originals where you can find the props I still use on a daily basis (see our web site for more information).

Use props sparingly and don't clutter an image with too many. Props can also be used to hide parts of a person that are a little heavy, and even hide parts of those who aren't overweight in order to enhance their body. A portrait needs to be about the person, and if you can pose someone with a prop that is sup-

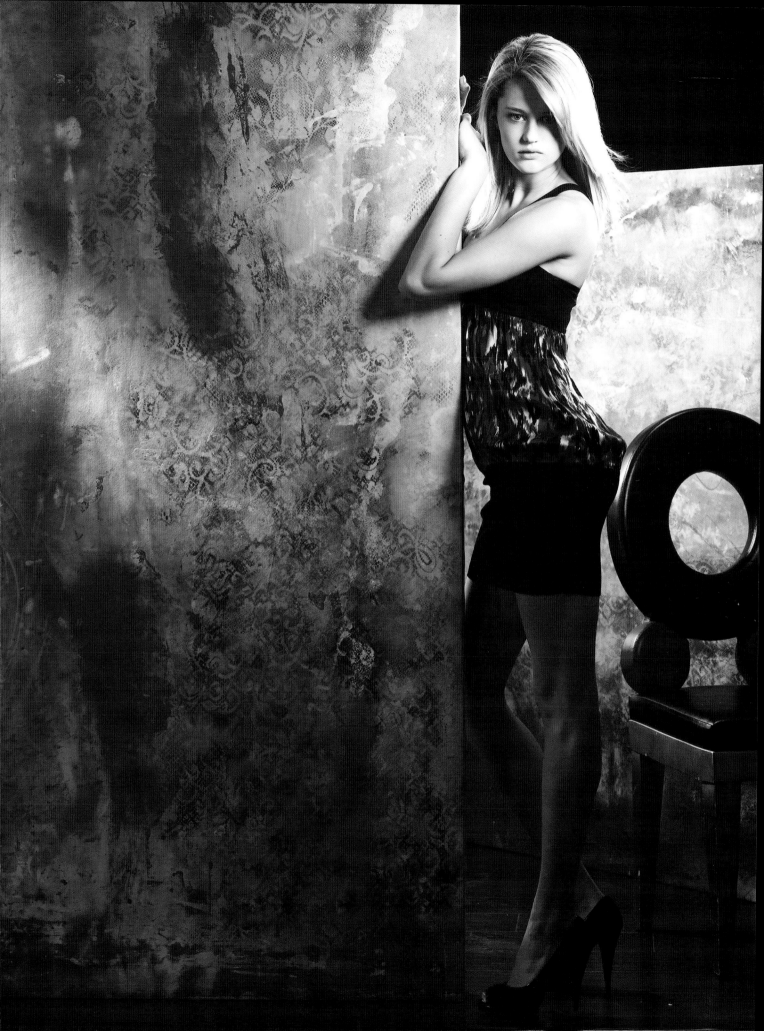

Courtney

portive or enhances that person, then you should consider it.

DISCUSSING WHAT YOU ARE DOING

I only discuss corrective posing when the client tells me they have a feature or body part they don't like. My job is to look at how I can enhance every client in front of my camera. Pointing out what you are doing may make the client realize that you are trying to downplay a problem area, and that can upset them. It is more important to keep up the energy of the session and make them feel good about themselves. Watch for problem areas and correct the poses to enhance the subject. Accentuate the positive.

FACIAL FLAWS AND EXCESS WEIGHT

It should be a given that you want to make people look great. If it takes placing part of their body in shadow or hiding part of their physique behind a prop, do it. There are probably more heavy people now than thin ones, and you have to approach them

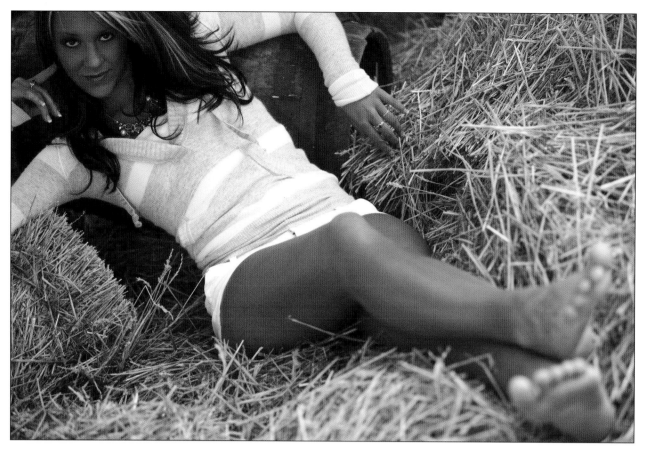

with a positive attitude because they may not see themselves as being overweight. Make your subjects look appealing in many poses, even some that they might originate. Always try to encourage flattering poses; you need to be imaginative to create irresistible portraits.

TEEN PORTRAITS

Photographing high school seniors on location is a growing trend. I'm not opposed to that, but in my career as a senior photographer I've tried not to follow trends, because they put you on the same playing field as everyone else. There are a lot of part-time photographers taking senior portraits on location to avoid the expense of a studio. This approach may be great to get started, but probably not for the long haul. I believe that the way to stand out is to do incredible studio photography with lighting techniques that help define you and props that take your work to a higher level. Try lighting that creates moods. Pick up ideas from more experienced commercial pho-

tographers. Study lighting in advertising, fashion, and upscale magazines and wherever you see great, professional portraits.

Many students are familiar with images in print, television, and movies. Your understanding of those various lighting styles helps separates you from location shooters. However, if students enjoy being photographed on location, I'm for it because they will buy prints that were made at places that have meaning for them. I'm talking wall prints—not just prints in an album.

Seniors do like relaxed looks in posing, and a truly comfortable pose will put them at ease. Just letting them do their own thing is a waste of time. It makes more sense to work with them to create dramatic poses lit properly. Limit your take, and avoid allowing teens to run around foolishly while you shoot hundreds of images. Overshooting takes more editing time, and the teens may not like the shots you pick. Be professional in guiding seniors and others, and don't depend on chance.

POSING GROUPS

A technique I learned years ago about posing groups is still of value. I begin with coins, with each one representing a person in a family or business group. I arrange the coins on a table, staggering them into a front row and second row with heads in a triangular composition. Every face should be seen, and those behind the first row need the most attention. The space between heads, front to second row, etc., should be triangular. If everyone is on the same plane, it is advisable to stand on a chair or short ladder to see each face fully.

Rows in a group should be close enough to be sure that the lens's depth of field covers everyone. If a staircase is handy to pose people on, it separates rows nicely. Make sure that the women in the photograph are posed in flattering positions, because if they are not happy, your group shot could be disappointing. Lighting on the whole group is usually quite even,

which also makes people happy. With today's cameras it is possible to photograph at higher ISO numbers and use an f-stop that ensures overall sharpness.

CLOTHING FOR PORTRAITS

Clothing can make or break a photograph. I try hard to get students and families to come to the studio for a clothing consultation. We've gone as far as to not make a definite appointment unless we've talked together first. I advise families to lay their clothing out to be sure it all goes together. Colors should be limited to three with one predominate. Shoes are often where people mess up. In a large group they are probably going to show, so grouping may be needed for some uniformity.

We ask clients whether they want a casual or formal look, and more choose casual. I prefer to photograph some families at their homes or outdoors in a complementary location. Formal to me means a more

posed portrait, perhaps in tuxedos or suits. This doesn't fit most lifestyles today where clothing and people are a lot more casual.

DIGITAL ALTERATIONS

We believe in switching heads to create the best portrait available. Some photographer's Photoshop techniques look tacky. If you're going to swap a head, the size must be perfect, the lighting on the face and the position of the body has to be correct. When I photograph a family portrait, I pose each individual in the family around the oldest person. I also photograph the members of the group individually. A client of mine had a father with cancer, and each of his children wanted a portrait with their dad in a location where they had a meaningful experience together. This was very touching and made me realize many families have stories that need to be told, even with alterations.

BODY LANGUAGE

Body language is important if you are trying to make a statement. It may be aggressive when an athlete is showing off, or when someone, male or female, wants to look sexually appealing. There may be as many different personifications as there are people who choose to be role playing when you photograph them. Body language can help add character to your portraits.

CAMERAS, LENSES, AND FLASH

I am currently using a Canon 1DS Mark III. My favorite lens is a Canon 70–200mm IS. I am leaning toward a ProFoto electronic flash.

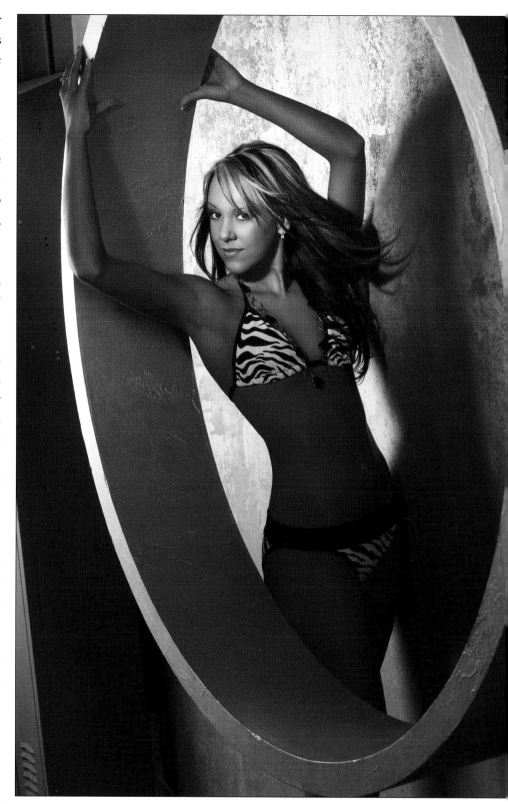

DAN HEFER

Born in South Africa, Dan Hefer is a third-generation photographer who at age eight learned darkroom work from his father, whom he assisted at weddings. At age twelve, he had a photograph of the moon published in an international stargazer magazine. It was taken through a friend's telescope with a twin-lens camera. "It was tricky to align the lens with the axis of the telescope," he says. At age thirteen, he shot his first solo wedding. Dan moved to the United States in 2000 and owns Heritage Portrait studio in Tempe, AZ.

MORE BACKGROUND

My father did 1950s-style Hollywood portraits, and when I began serious work, they seemed so dated. My work had a more Rembrandt-like, classic look. In my late teens, I apprenticed to an old German professional color printer from whom I learned some choice adjectives to describe mistakes. The first week I retouched rejected prints and discovered how to mix colors.

When I joined an aerial photography company, I made the first color mapping mosaics in Africa. Later, I worked for Agfa, where I learned to manage a large group of perfectionists who spoke some English but mostly German. Equipment manuals were written in German, so I soon became proficient in that language.

In the Army, I served two years in South West Africa under a German sergeant who took to me because I spoke his language. Eventually I worked for

and managed an industrial photographic department at ISCOR, a huge iron and steel plant. I did portraits and weddings part time and eventually opened my first studio in Newcastle Natal, South Africa. I outgrew that and opened a second studio in Durban, a major city. For a year, I commuted more than 100 miles one way between my two studios.

I did photography, printing, everything, and in 1981, I made my first canvas-mounted print (these prints are still my main product). I have worked with a wonderful array of methods and equipment, was chairman of various professional organizations, and have had several one-man exhibitions.

DESCRIBE YOUR STUDIO

When I came to the United States I had grown restless with South African politics and violence. To help me integrate into the American business model I worked for several photographers, and then purchased Heritage Studio in 2001. Almost immediately the country faced a business crisis, but I have prospered yet again. The studio serves upper-middle-class clients. I don't do a high-volume business, so I work alone because I enjoy running a studio but not managing people.

YOUR SPECIALTIES

My studio does mainly family groups, executive portraits, high school seniors, and some child photography. I gave up shooting weddings on my fortieth birthday. I enjoy the studio lighting, posing, and backgrounds, plus the control I have. I also get pleasure from working outdoors on location. Weddings were great training for location shooting. You work in unfamiliar places, making decisions about posing that are influenced by the time of day, the season, and the weather. I constantly look for new locations, and I consider the lighting conditions I will face in old ones.

GETTING ACQUAINTED WITH CLIENTS

I find it very helpful to meet my clients before the shoot. I am a good photographer and a poor psychic.

To be familiar with client expectations, I ask specific questions that lead me to make informed decisions about approaching individuals. A pre-shoot consultation also gives me a chance to educate customers about what makes a good portrait. Most people don't have much photo education and may not understand that what they wear will influence the outcome of the shoot. Examples of good poses and explaining how lighting and shadows define and flatter the subject can come as a surprise to many people.

I also find that portraits to please a husband may be different from portraits intended to be given to someone's mom. I shoot variations because some poses can't fill varying needs. A business portrait is unlikely to appeal to grandchildren.

I explain what types of clothing and shoes will be most suitable indoors or out, and that t-shirts and jeans don't mix well with their Italian hand-carved chairs. Individual personalities dictate how the shoot goes and how the photographer needs to adapt. A customer who likes you will probably like your pictures. I have worked with Ice-T the rap artist, and the next day I photographed the Kingston Trio. Not surprisingly, they wanted different types of poses and moods. Some people like classical music and some like country. It's the same with portraits, and it's the photographer's job to know what to give the client.

PREPARING POSES

After consulting with a client, posing becomes easier. You both understand what you are looking for, and choosing poses that will be best suited to individuals is simpler. Even so, when I photograph people I generally demonstrate poses and explain what to avoid. Most clients think that they are standing straight with good posture, so making them aware of the contrary is useful. Once you have the person posed, distract them just enough to help them relax and look great.

With family groups, I explain that their height or age may dictate where they stand or sit. With large groups, you need to keep everybody's attention at the same time, and you may need a gimmick. I tell adults that they are responsible for their own expres-

sions and I may even tell them to "smile and look at the camera," but only if they can take a joke. Most often the mothers of small children are hardest to capture in a group; they are so busy worrying about the child's face they forget their own expressions. I have a set of ducks, some rubber and some fluffy and soft, and I may threaten to throw a ducky at anyone who does not pay attention. Sooner or later someone gets a duck bump, and that's so funny that afterward I just say "Duck!" and everyone is looking at me with a smile. The kids like it even more, and they laugh too.

FIRST PORTRAIT POSES

I like to portray individuals in head-and-shoulders poses, because that's the area of the body that is engaged in conversation. As I shoot I try to talk, and sometimes I need to use more body language for emphasis. A lot of people cannot pose at all and must be directed. Some are stiff and clumsy, while others are like liquid gold to work with. A head-and-shoulders pose is a good starting point for reluctant posers.

ENCOURAGING IMPROVISATION

I always encourage individuals and small groups to participate in the shoot. I sometimes ask them to pose themselves and then I tidy it up. My portrait style works best with preconceived poses, and I have not had much success with client improvisation.

INSPIRING GOOD EXPRESSIONS

Working with the public means that one needs a large repertoire of smile makers. I settle my clients in by sitting with them in the reception area and making small talk, then we slowly progress to the stu-

dio. With children, I sit on the carpet and play high-five or build a wooden block tower that they knock down. In the studio, jokes work with boys aged three

to six. Girls the same age respond well to secrets whispered in their ear. Both will smile every time you hint at a joke or whisper.

The phrase "stinky feet" often works but can easily get out of control when a child becomes silly. This takes patience. Most men will smile if you say the words "golf" or "money." "Shopping" works for women. These are superficial things, and true smiles for teens and adults come from more intimate interests. Compliments or light teasing always get coy smiles if you have set things up for them to be receptive.

THE IMPORTANCE OF LIGHTING AND CAMERA ANGLES

Lighting can greatly influence the sitter's opinion of the final results. Diffused light from a softbox is usually best for portraits. Butterfly lighting (a shadow created under the top lip) works well to hide a turkey neck but does nothing for a bald head. The more symmetrical the face, the flatter the lighting can be. A lazy eye should be on the shadow side. Round faces benefit from more contrast. Males look more masculine with higher contrast, such as 1:5 or 1:7. Females are generally lit softer at 1:2 or 1:3. Fashion images are even softer, with a 1:1 light ratio.

Camera angles are also important. An angle below a subject's eye level can impart a sense of importance. Positioning the lens at eye level makes a face more communicative. A high angle can help improve the appearance of aging necks or droopy eyes.

USING PROPS

I'm not a fan of "over propping" a portrait. If someone plays the piano, you don't need to include the whole piano in the frame to show this. Sheet music with the words "for piano" on it may do just fine. Props should be appropriate and must enhance, not dominate, the portraits. A motorcycle helmet is enough. For children, I like to keep portraits as plain as possible. I'm not a product photographer or storybook illustrator. When you use props to show what interests a high school senior has, they shouldn't distract from the subject. A senior with guitar in his lap can be portrayed in a graceful pose.

DISCUSSING WHAT YOU ARE DOING

Occasionally it's a useful distraction to explain what you are doing with the lights. It can help an uneasy subject to relax. Technical discussions are okay when the subject asks leading questions, and they can increase cooperation. Mostly you need to pay attention to how your subject feels in front of the camera and act to relieve any stress. But be careful not to make the subject too conscious of their surroundings or of your techniques.

FACIAL FLAWS AND EXCESS WEIGHT

None of us are perfect, but some want to be. Photographers face client ego problems. We often photograph people who do not want to be photographed and we have to convince them that their pictures are terrific. Then we have to sell them these pictures so that we can do it all again tomorrow. I may explain to a realtor that his or her portrait is not for Internet dating or entering a beauty contest. It's just to introduce him or her to a prospective buyer who wants to see someone they can trust who looks competent. If a realtor's portrait doesn't look like the person, then the buyer may construe it as misleading.

That said, we do need to make the most of our subjects. So for bald heads, use no hair light and slightly lower the camera angle. For a broken nose, turn the head to show straight up the nose bridge.

With a round face, use a three-quarter view and 1:5 lighting ratios, and shoot from the shadow side. For wrinkles, use a large softbox with soft-focus filters. Heavy people should wear dark outfits or vertical stripes and consider doing only headshots.

TEEN POSES

Senior portraits are full of potential. Some teens seem to have multiple personalities, and I try to capture them all—grumpy, insecure, astute, competent, etc. Peer pressure plays an important part in senior sessions. Some want a certain pose because their sibling or a special friend had one. They are more active than we adults are, so I capture more energy in teen shots.

LOCATION POSES

Outdoors, I select the background first, exactly as I want it, and I add the people. I always expose for the background and use fill flash for a group, which gives a natural-looking portrait. When an outdoor scene might overpower the subjects, I underexpose the background by half a stop to a full f-stop. This adds emphasis to the subject. Generally an outdoor portrait is a scene with people in it, and posing is more relaxed because of the ambience.

POSING GROUPS

Consider locations by a wall or a backdrop, indoors or out. Floor covering, furniture, background, outfits, etc., should relate to each other. In the studio I have more control, and people don't have to worry about a home setting.

I always photograph big groups from slightly above eye level. I start with the oldest members in the middle. I try to shape the group with the edges closer to me than the center. If they are in jeans and t-shirts, I will not use formal chairs. I always photograph elders in any groupings they want, at no extra charge. Each grouping is a sales opportunity, and everyone will want a picture of the patriarch(s) and/or matriarch(s).

Large groups are a mainstay of my business, and what they wear is important. A family dressed in too many colors and patterns risks looking like a fruit

salad in a print. Suggest that they coordinate their clothing for the session. An easy way to explain the importance of coordinating clothing is to say that one does not normally wear green shoes, pink socks, orange pants, a yellow shirt, and a blue tie. A group looks better in harmonizing clothing.

When a group member is absent the day we shoot, he or she is invited to the studio for a portrait with lighting that matches the group, and I add the person digitally. I also may do a head swap to place a better image of a person into a group portrait; it is a service for which I do not charge. A number of individuals are going to put a little billboard of themselves in their homes with my name on it, and I want it to be the best I can do.

EXECUTIVE PORTRAITS

Executive portraits are also an important part of my business. Subjects may be a realtor, an author who needs a photo for a book jacket, or a public speaker who want a pictures for a house newsletter or a local newspaper article. The main rule here is to make the subject look competent, confident, and approachable. Look at the portrait and ask yourself, "Would I buy a used car from this person?" If the answer is yes, it's probably a good business portrait. If the subject has a specialty and you can include a prop that indicates that, shoot it as an alternative, too. Posing highly paid or famous people requires more delicacy than photographing a neighborhood couple. Conventional posing and lighting are usually called for.

EQUIPMENT AND BACKGROUNDS

I use a high-end Nikon digital camera. When photographing people, I always use the longest lens that is practical, at least 85mm. For indoor groups, I like 24mm or longer. Outdoors I use my favorite zoom lens, a Nikkor 17–55mm f/2.8. I also have the S2 and S3 Fuji digital cameras, and I use them on occasion. My studio flash is a Norman. On location, I use a Nikon SB-800 flash or my trusty old Metz CT 60-4.

I have forty backgrounds that are hand painted as well as old barn wood nailed to a full wall, plus other backgrounds that I use for special events.

POSTPRODUCTION

I print all my own work in house with an Epson 9800 on Kodak papers and Epson canvas. The public may still be nervous about inkjet prints, but with the Kodak Pro paper stamp on the back of the images, most people will not question the quality. I do not mount or frame, but I let people know where those services are available.

ANGELA STOTT

www.angelastott.com

Angela Stott of Asheville, NC, took her first photography class when she was twelve years old and also took art classes in Winston–Salem, NC, where she grew up. When she reached twelfth grade, she spent half of her day in her high school and the rest of it studying art and photography on a college campus. At Prescott College in Arizona, she studied art and carried a film Canon Rebel to photograph mostly landscapes, friends, and sometimes nudes. She graduated in 1995 with a degree in art. She works mostly in North Carolina and Virginia but has portrait clients in Bangkok, Thailand, as well.

MORE BACKGROUND

After college, I worked various jobs and became an at-home mother in 1998. When my son was three years old, his father and I separated and I began teaching yoga. In 2001, after seeing a show of infrared nude photography, a photographer friend of mine, Jason Gallo, gave me a one-day camera tutorial, and I spent the next two years shooting black & white infrared film. Handcoloring prints also enabled me to develop my sensitivity to composition and light. I did infrared landscapes, night scenes, performers, and more nudes in the United States and on a trip to Thailand.

When my sister, Eleise Theuer, began shooting portraits professionally in Winston–Salem, NC, she encouraged me to do the same. Living then in Prescott, AZ, a somewhat economically depressed area, I couldn't imagine that anyone would be able to

years' worth of my work. I held a small show that attracted portrait clients, mostly expatriot families.

I became a professional portrait photographer overnight. In my first three months, I took some of what are still favorite portraits. Clients loved my work and said it was different. My sister helped me catch up in the digital age, but I still shoot film as well. I've been inspired by the work of Mary Ellen Mark, Sally Mann, Annie Leibovitz, and Diane Arbus. My sister, now a very successful wedding photographer, continues to encourage me.

ABOUT YOUR BUSINESS

I settled in Asheville (population 80,000) in 2007 and work out of my home office and on location. My business was actually built in Bangkok (population over 14 million). I've traveled

afford professional portraits. I focused on being a good yoga teacher and went to Thailand again with my son where I located a good printer who enlarged

there countless times since 2001 and have also lived there. In contrast, it takes time to build an appreciative clientele in Asheville. I've found that it is important to show finished, framed prints that allow people to imagine their own images on display in their home.

In the United States, I have part-time employees who assist at weddings and help with processing, editing, print orders, and bookkeeping. I do portrait sittings alone in the United States, but I have an assistant from Ashland, OR, who travels with me to Bangkok when I do portraits there. I have also had representatives working for me in Bangkok on occasion (for marketing).

YOUR SPECIALTIES

I photograph families, children, individuals, and weddings. I carefully scout shaded outdoor portrait locations, where the textures and light are suitable. I enjoy compelling settings where a need to improvise spurs my creativity. I often set up a backdrop and create a studio look for part of a sitting. I also scout my client's home before the sitting if they request it, and if it's not right I choose a location depending on the ages of the people, the time of day, and my schedule. I carry props with me and enjoy finding more on location to improve the composition and give people a place to sit that blends with the environment.

GETTING ACQUAINTED WITH CLIENTS

I follow a client's lead when it comes to getting to know them. I want them to trust me, so I'm as natural as possible, and within the first hour people relax. That's essential, because I demonstrate sprawled and perched positions, and they are disarmed. While I'm shooting, I carry on small talk that helps keep faces expressive and alive. Involved people pose more gracefully. To help them lighten up I have them walk without looking at me while I shoot. This may be called mobile posing. I augment their activity by asking them to jump or throw their heads back and laugh. Most people enjoy these animated poses. At times, I ask a client to sit very still and simply look directly at the camera. Small talk elicits changing expressions. Capturing peoples' images is a collabora-

tion of efforts, and the final photographs are our rewards.

PREPARING POSES

I like to begin a session photographing the close-ups. This is especially true with small children because

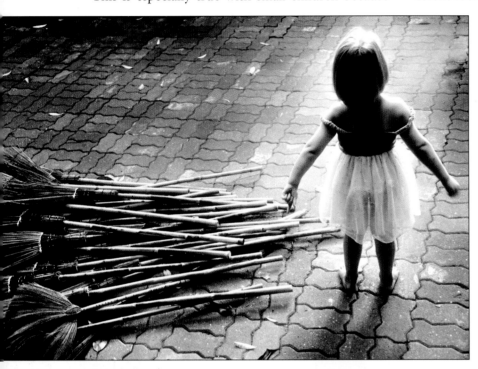

their curiosity is at its peak early on, and being still and looking at the camera is easier. While photographing a family, I usually start with the youngest and continue with individuals, then pose them in a group. I return to working with individuals in a different location, and return to the group in still another location throughout the session, loosening my posing requirements as we progress. As the session wears on, grownups relax more and children become more spontaneous.

I keep poses flexible and I often switch camera angles rather than move my comfortable client. I may ask for poses that could feel a bit awkward, but they look natural. If people feel awkward but look great, I'll tell them so. Having taught yoga, I'm pretty good at directing peoples' movements.

People are challenged when they try to perform for the camera and fail. I might tell them to take a break and shake themselves out. Then I direct them to different poses to keep them moving and keep

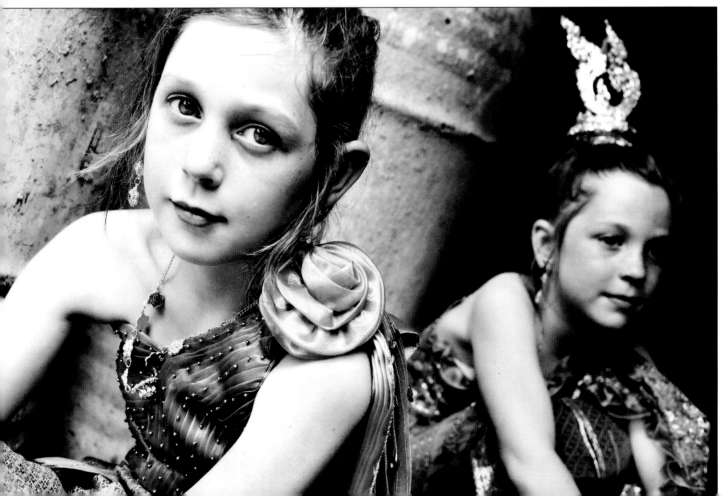

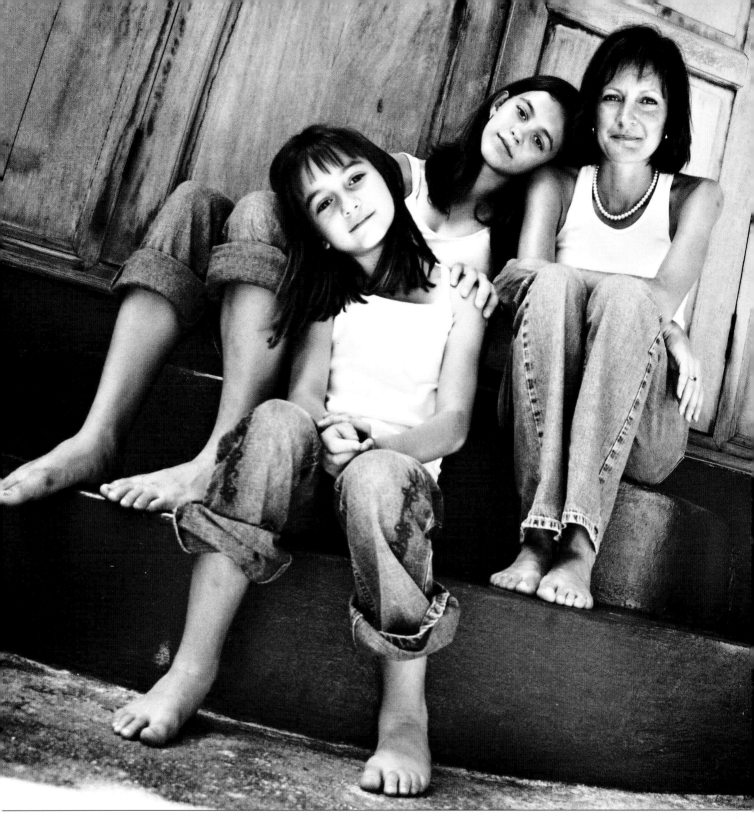

things fluid. One of my favorite suggestions is, "Trust the process. Even if you feel weird or contorted, you are creating compelling, fresh images of yourself."

Body language achieves variety, and that ultimately sells more images. For example, I might photograph a person with their arms crossed and bent at the elbows, chin lifted slightly—a strong, closed pose. I might also photograph them with their hands posed loosely on their hips and their body angled sideways and leaning forward. It is a strong pose, and it's provocative and open. Think about offering variety. It will only help to build your sales.

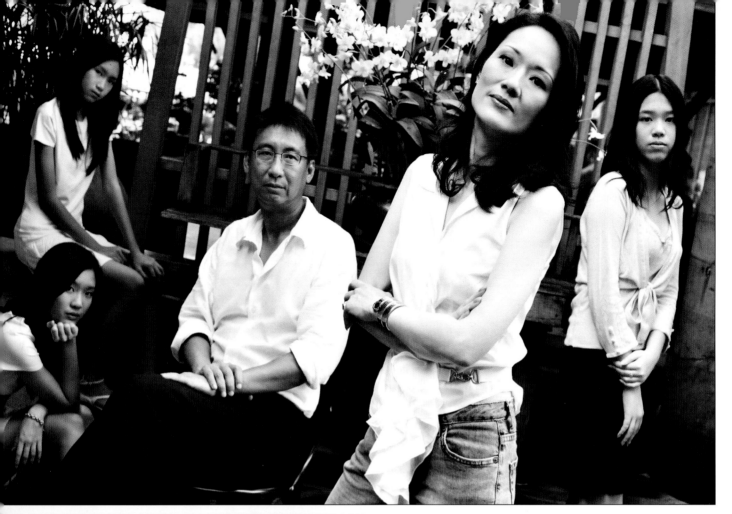

face toward the sun. These poses are especially popular. As an alternative, I have one half of the face in a soft shadow at an angle where catchlights are visible. For full-length poses I follow the same principles, but because I am farther away I'm more concerned with composition.

INSPIRING EXPRESSIONS

I encourage improvisation because spontaneous poses are often the best. I direct as little as possible and surrender to what happens naturally, which is often better than I could have predicted. I discover what people like and find entertaining and then give them as much of a sense of importance as possible.

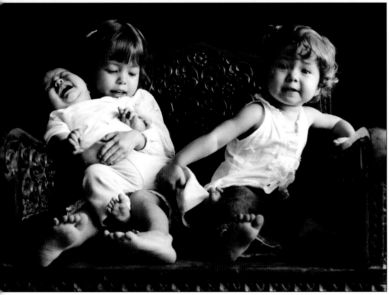

FIRST PORTRAIT POSES

My sessions may run three hours and include numerous poses. Initially I shoot head-and-shoulders poses, paying close attention to how light is reflected in the subject's eyes. For the best light, I place the person under a cover (like a porch) and angle their

THE IMPORTANCE OF LIGHTING

When I am shooting on location, I fit the subjects into existing lighting situations and that's what dictates the posing. I try to keep the photography very simple. I search for enough light for good exposures and turn my subjects' faces into the light. I like back-

lighting as well for the wonderful halo effect it creates. I bring along something for people to sit on and often shoot with the subject facing the camera but looking away. Every image shown in this chapter was shot on film. I used to shoot 90 percent film, but I am now shooting digitally 90 percent of the time.

POSING YOUNG CHILDREN AND USING PROPS

Children three and under don't take well to posing suggestions. Four- and five-year-olds will pose briefly, so stay open to their natural movements. Give children a task that directs their bodies into particular positions. Allow small kids to hold onto something while you talk to them. Sing to babies and younger children. With kids two to five years old, make up games or phrases or tell them to look for their reflection in the lens. Have them jump or be still on the count of five. Ask them to lean against a wall. Praise a child for being so good at posing.

My job is to create photos a family will love, and when you have a distinct vision of how images should look, you will use any means at your disposal to hold a young child's attention or create a lovely reaction. Sometimes I am trying to conjure a comedic bond between us. If I place a child on a chair next to an adult, I might suggest that the chair is a boat, and if they climb down, little fish might nibble on their feet. They laugh, and I lunge for their feet every time they try to "test the water." With a group of siblings I might tell them all to sit in the same chair, and as they mash themselves together I catch them giggling. If they end up frustrated, such impromptu poses can be quite endearing.

The following props apply to various ages: bouquets of flowers, dress-up clothes, Mom's shoes, Dad's glasses, Grandma's wedding gown, capes, crowns, and wigs. Musical instruments, toys, bubbles, face paint, masks, handheld mirrors, cowboy hats, ballet shoes, and tutus are great options as well. You will think of others.

DISCUSSING WHAT YOU ARE DOING

I exclaim "ooh" or "ahh!" when I see a pose or ex-

pression I like. I may remark about beautiful sun in a woman's hair. I want subjects to feel photogenic. Sometimes for group portraits I tell the subjects to pretend this is their rock star picture and we're shooting an album cover. They get turned on and lift their chins, stand in more powerful, provocative ways. It's appealing fantasy and takes very little readjusting.

FACIAL FLAWS AND EXCESS WEIGHT

I have photographed people with flaws and fell in love with their images but have heard other people say something like, "She has a horse face." That doesn't trouble me. Some "flawed" individuals are actually more photogenic than "pretty" people. I overshoot challenging people. Sometimes I see what works best when viewing proofs. I don't view flaws as their problem, but mine.

One way I handle overweight people is to place them in a corner and photograph just their head,

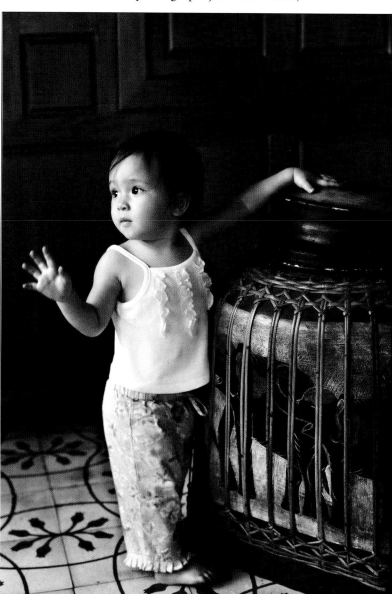

shoulders, and maybe part of their upper torso. I choose locations where the lighting flatters them, and I also create some moody shots.

I also photograph overweight people from above to accent their eyes and make their body appear smaller. V-neck sweaters create an impression of length. I recommend clothing that is attractive and I may discreetly ask someone to adjust a pose to hide bulging areas.

I sometimes minimize wrinkles by shooting at f/2.8 and focusing on wrinkled eyes, but I don't entirely remove wrinkles in Photoshop. I choose a lens like an 85mm to keep people's proportions intact.

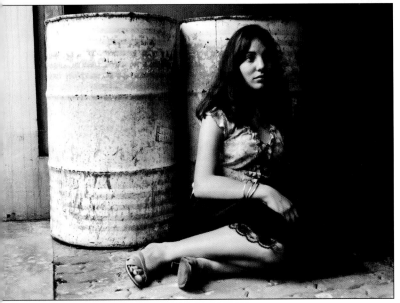

TEEN POSES

Teens are usually flexible and relaxed, and I might ask a teen to crouch or curl up in various poses that I would not ask an adult to do. These subjects may bring props related to activities they enjoy; if so, you can help select the more photogenic ones. Teens are usually good for discussions about what they love to do and as they relax, their poses and expressions become good portraits.

You may treat teens like adults, ask them how they would like to pose, and praise their choices. I love photographing teens from the side and from below to give them an air of confidence and strength. I have them open their eyes and look up into the light—that makes their faces come alive. Parents always love laughing poses.

Some teens are gangly and some clothing choices don't show them at their best. Focus on finding poses that flatter and on their agility. For teens with poor skin, I angle their faces directly at the light and slightly overexpose or hide their worst side in shadow.

POSING GROUPS

You can get good group shots when you stand on a ladder and shoot from above the group. I sometimes ask the subjects to sit on the floor, pointing their feet away from me, or to stand and look up. I see people clearly in the second and third row this way. If everyone is looking up, the light is usually even on their faces. Sometimes I start with a couple of people very close together, posing them one at a time. I offer suggestions and demonstrate. Poses fall naturally into place when people are given a role to play. If some people need more light, I use a reflector.

I'm willing to play with group composition, and I tell the group I'll be moving people and making small adjustments until everyone is just so.

With a group all on the same level, I may shoot below their chin level. I place one person, typically the mother in a family, in a strong pose, perhaps with her hands on her hips. I place the father slightly behind and to one side of her, maybe with his arms crossed. The children are grouped around them. I

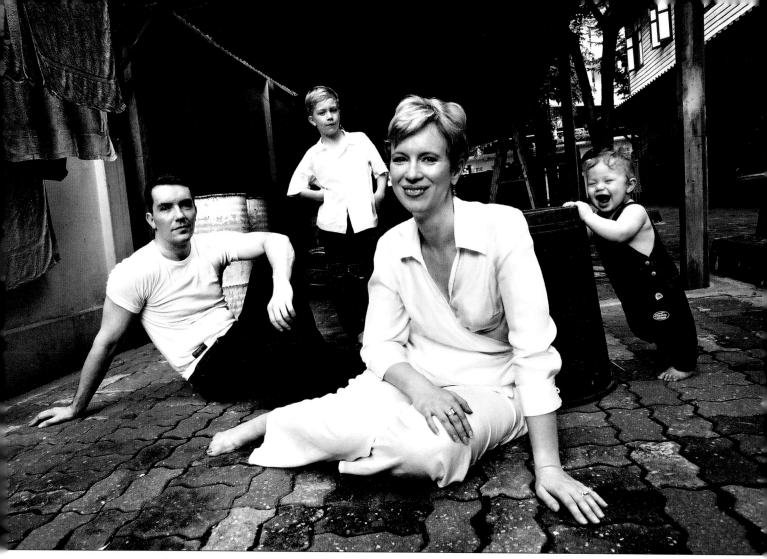

try to space people so that they have room to breathe.

Some photographers try to avoid the formality of group portraits, but nothing sells better, even in larger, wall-portrait sizes, than well-composed family shots. You can be as creative as the group allows. Every family is different.

ADVICE ABOUT CLOTHING, ETC.

Our clients are given some guidelines regarding selecting clothing, makeup, hairstyling, etc., before they arrive for their session. These tips appear below:

- Wear what's comfortable and flatters you.
- Pastels and bright colors work equally well.
- Shoes should make a statement of their own.
- Avoid tan lines or sunburn.
- Wear your hair the way you like it.

- Wear makeup as usual and apply mascara carefully.
- Come with a fresh shave.
- Trim and file nails and remove old nail polish.
- Bring magazine clippings for portrait posing ideas.
- Group colors should complement and contrast with each other.
- Babies under six months photograph best in the nude or in a diaper.

CAMERAS, LENSES, AND FLASH

I use a Canon 5D for digital work and a Canon 1V for film. Traditional close-up portraits are wonderful when shot using an 85mm lens. I also use 17mm, 20mm, 24mm, 50mm, 105mm, and 200mm lenses. My zoom lenses are 70–200 L and 24–70 L. My Canon Speedlite 580EX II is sometimes set up remotely with a Pocket Wizard. However, I mainly depend on natural light and sometimes a reflector.

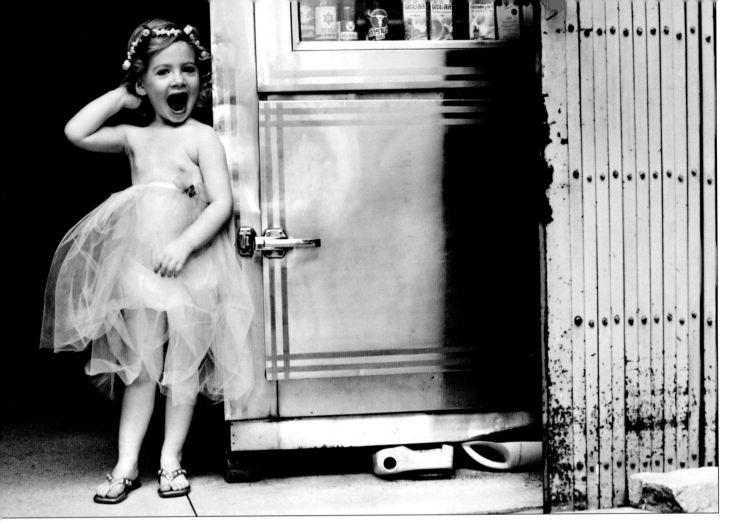

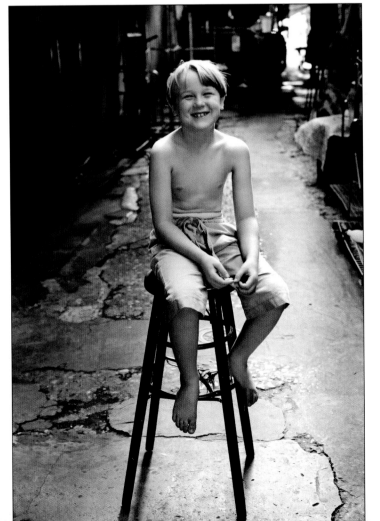

END NOTES

I'm an intuitive shooter. I shoot what looks real, not contrived, because it simply *is*. My intention as a photographer has always been to just capture what I see. I certainly spend time posing my subjects, but that is secondary; I'm much too busy making sure my camera settings are ready for a perfect exposure. I am more fascinated by composition and light than in gaining insight into my subjects' psyches. My hope and observation is that my clients will find the deeper meaning in my work. I love witnessing the smiles and tears of joy when my clients see the photographs I take of their families. I love knowing that I have a positive effect on people that lasts for generations.

CONCLUSION

I have just read the page proofs of this book. Doing so renewed my feelings about how the advice offered by ten photographers should have been of value to you, the reader:

- Every participant emphasized that good lighting is necessary to effective posing. When you put effort into posing someone, be certain they are lighted in ways that display their expressions and body language.
- There are all sorts of smiles, and they are important to most portraits and to commercial work, depending on the product or service advertised.
- Many photographers credited being creatively influenced by images they saw in print and on exhibit. Be observant: visit galleries and museums and see what your competition has on display.
- Contributors to this book came from various backgrounds, but many were assistants to other photographers on their way to owning studios or freelancing.
- Everyone said they engage subjects in conversation as a valuable way to create attractive poses and expressions.
- I enjoyed realizing again how husbands and wives, parents and children, unrelated business partners, and individuals were all successful portrait and commercial photographers. It's nice to know there is no one formula for success. Parts of a formula, of course, are resourcefulness, ingenuity, talent, and a pleasing personality.

Have a fulfilling career.

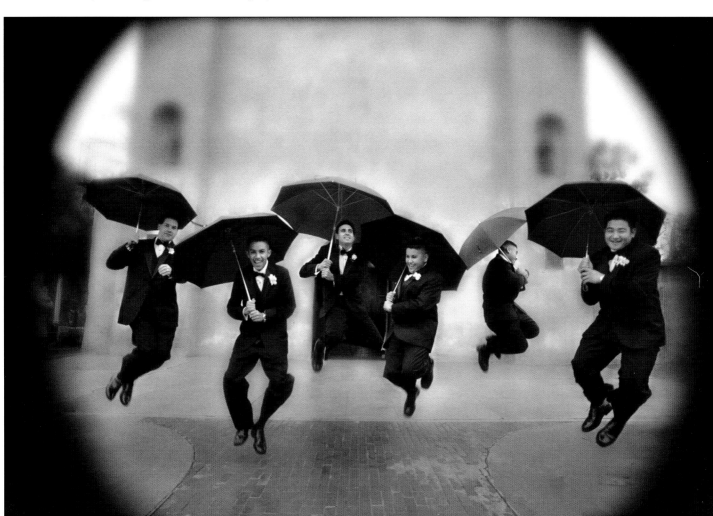

Photo by Elizabeth Etienne.

INDEX

A

Advertising photography, 10, 48, 81, 82, 83, 84, 98

Albums, 26, 59

Art directors, 10

Assistants, 60–61, 117

B

Babies, 14, 15, 48, 60

Backgrounds, 23, 35, 44, 45, 55, 66, 98, 113, 117

Backlighting, 52, 66, 68, 97

Blogs, 61

Body language, 23, 38, 45, 57, 79, 90–91, 103, 119

Bouchér, Marissa, 24–35

Boudoir photography, 25, 26

Brennan-Harrell, Sara, 58–69

Business portraits, 79, 96, 113

C

Camera height, 15, 45, 79, 110

Camera selection, 23, 45, 57, 69, 80, 91, 103, 112, 123

Celebrity portraits, 10

Character studies, 10

Children, posing, 22, 44, 52, 55, 77, 78, 86–87, 121

Clothing, 22, 35, 38, 45, 55, 79, 102–3, 108, 122–23

Commercial photography, 62, 73, 87

Communication, 9, 38, 48–49, 64, 72, 83, 87, 117–18

Composition, 22, 31

Contrast, 76, 110

Couples, 16, 50, 55, 75

D

Displays, portrait, 26

Doisneau, Robert, 47

E

Editorial photography, 10, 14

Elderly subjects, 55

E-mail, 61

Engagement sessions, 50, 75

Etienne, Eliabeth, 47–57

Expressions, 9, 10, 16, 28, 42, 45, 51–52, 75, 97, 109–10, 120

F

Family photography, 14, 23, 48, 62–64, 73, 98, 106

Fashion photography, 10, 18, 22, 31, 35, 77, 101, 110

Flash, 23, 35, 45, 54, 57, 66, 80, 91, 103, 113, 123

Flaws, physical, 22, 28, 32, 41, 42, 52, 54–55, 68, 76, 77, 84, 85–86, 100–101, 111–12, 121–22

Fund-raisers, 72

G

Greer, Julia, 12–23

Group portraits, 14, 16, 22, 23, 35, 42, 44–45, 48, 55, 62–64, 71–72, 73, 77, 78–79, 87, 96, 98, 102, 106, 112–13, 122–23

H

Handcoloring, 115

Hefer, 104–113

High key, 26

Home, working in client's, 15, 37

I

Image editing, 22–23, 45, 55–57, 68, 79, 87–90, 103

Improvisation, 18, 41–42, 64, 75, 96, 109

Inspiration, 9–10, 31, 101

Interns, 60–61

ISO, 66

J

Jacobson, Ron, 70–80

Joyce, Todd, 81–91

L

LCD screens, 68, 96

Lens selection, 10, 23, 35, 45, 57, 69, 80, 91, 103, 112, 123

Liebovitz, Annie, 47

Lighting, 9, 18, 23, 35, 42–43, 45, 48, 54, 57, 66, 68, 72, 76, 79, 80, 84–85, 91, 97, 103, 110, 113, 120–21, 123

ambient, 66

backlighting, 52, 66, 68, 97

butterfly, 18, 75, 110

diffused, 54

flash, 23, 35, 45, 54, 57, 66, 80, 91, 103, 113, 123

(Lighting, con't)
 flat, 18, 42, 48, 52
 loop, 1
 natural, 18, 54, 66, 120–21
 open shade, 66
 Pocket Wizard, 66
 reflectors, 18, 54
 Rembrandt, 18, 76
 rim, 54
 scrims, 76
 short, 18
 side, 84
 silhouettes, 52
 softboxes, 23, 66, 72, 97
 split, 52, 76
 spotlights, 76
 strobes, 18, 23, 25
Litchfield, Melanie, 58–69
Location sessions, 7, 9, 14, 38,
 60, 61–62, 71–72, 94,
 106, 112
Lying poses, 28

M
Magazines, 35, 50, 98
Marketing, 59, 73, 94
Models, 10, 82, 83, 84, 85
Mood, capturing, 62, 85
Music, 10

N
Natural light, 18, 54, 66,
 120–21

O
Outdoor portraits, 18, 35, 48,
 60, 106

P
Personality, photographer's, 15,
 38, 48, 73–74
Peters, Larry, 92–103
Posing lengths, 7–8, 15, 41, 65
 full body, 7, 15, 31–32, 41
 head and shoulders, 7, 15, 41
 three-quarter, 7, 15, 41
Postproduction work, 69, 113
Pricing, 61
Product photography, 10
Props, 15–16, 21, 32, 41, 68,
 77, 85, 98–100, 110, 121

R
Referrals, 61
Reflectors, 18, 54

S
Sales room, 26
Seated poses, 28, 65
Seniors, *see* Teens
Sets, 10

Shoot list, 51
Skin, 18, 35, 52, 54, 91, 122
Smiles, 16
Softboxes, 23, 66, 72, 97
Spotlights, 126
Standing poses, 28, 66
Stepladders, 35, 45
Stott, Angela, 114–24
Strobes, 18, 23, 25
Studio sessions, 7, 14, 26, 37,
 48, 60, 71, 82, 93–94, 106

T
Technique, discussing with
 client, 21–22, 32, 43, 54, 85,
 100, 121
Teens, 10, 14, 18, 22, 75,
 77–78, 86–87, 101, 112,
 122

W
Web sites, 9–10, 50, 59
Wedding photography, 25, 26,
 48, 59, 60, 66, 75, 106
Weight, excess, 22, 28, 32, 41,
 42, 52, 54–55, 68, 76, 77,
 84, 85–86, 100–101,
 111–12, 121–22
Woman Captured, 25, 26, 32
Wright, Carolyn, 36–45